Painting **Recipes**

Landscapes

BARRON'S

Painting Recipes

Landscapes

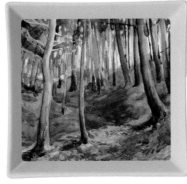

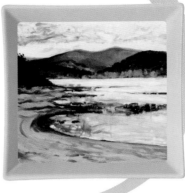

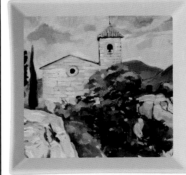
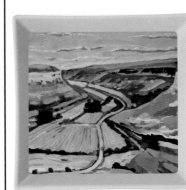

Recipes

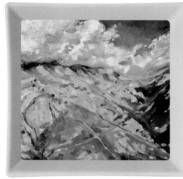
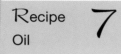

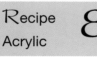

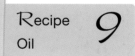

Appetizers

savoring the landscape

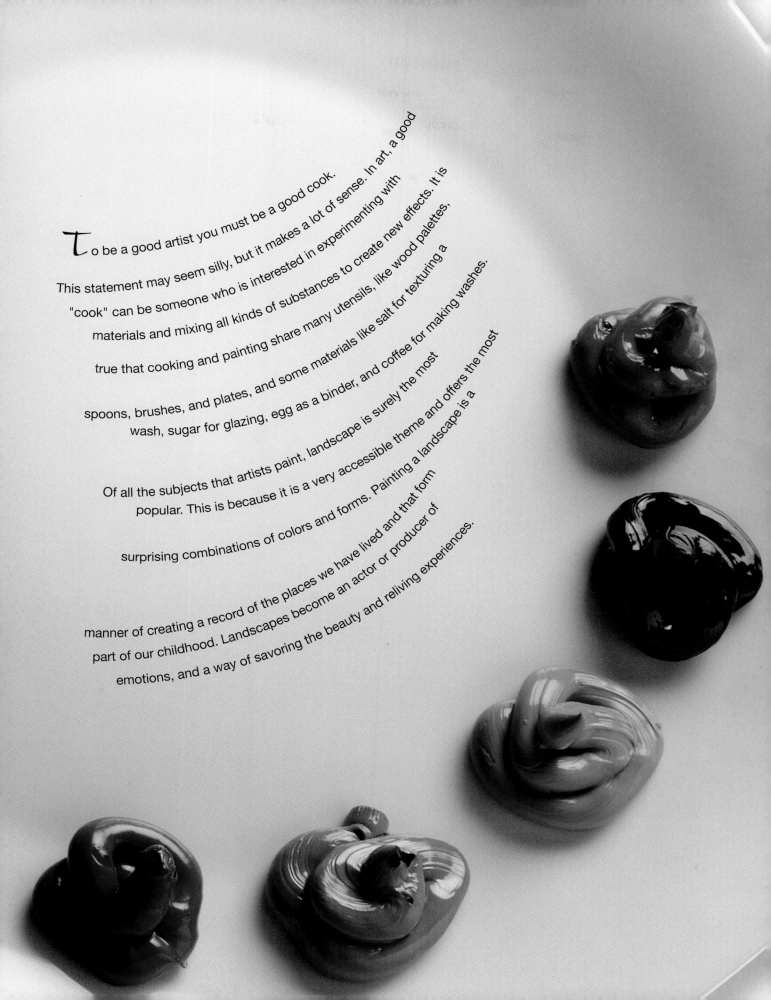

To be a good artist you must be a good cook.

This statement may seem silly, but it makes a lot of sense. In art, a good "cook" can be someone who is interested in experimenting with materials and mixing all kinds of substances to create new effects. It is true that cooking and painting share many utensils, like wood palettes, spoons, brushes, and plates, and some materials like salt for texturing a wash, sugar for glazing, egg as a binder, and coffee for making washes.

Of all the subjects that artists paint, landscape is surely the most popular. This is because it is a very accessible theme and offers the most surprising combinations of colors and forms. Painting a landscape is a manner of creating a record of the places we have lived and that form part of our childhood. Landscapes become an actor or producer of emotions, and a way of savoring the beauty and reliving experiences.

Materials and Techniques for a Singular Landscape

As new materials have become available, the possibilities of interpreting the landscape have increased, and a host of new approaches have appeared. These approaches combine a fascination for exploring the natural world with new technical solutions that offer a unique vision of figurative representations of the landscape. More and more, artists are painting the landscape in a less stiff and rigid manner, in accordance with new forms of expression that are more original, free, and closer to the subjective vision of the artists. They have also lost their fear of combining different painting techniques in the same painting, and of adding substances that alter the consistency of the paint. In this case, the end justifies the means because mixing paint, fillers, glue, varnishes, and so on creates many possibilities for landscapes, which can be infinitely varied and present the most surprising combinations of shapes and colors. You must learn to appreciate the chromatic possibilities offered by the subject and also develop your creativity and ability to interpret them, changing and making up new colors as you need them. In the following, those of you who have not yet learned to freely and fearlessly represent the landscape will find many new ways to represent nature, but from now on with a renewed and much more expressive look.

Oil medium has a gelatinous appearance, it is not completely transparent, and it does not alter the color of the paint.

Gel or modeling paste is a synthetic substance that is used to add volume to the paint.

Incorporating Synthetic Materials

There are many synthetic substances like gels, varnishes, enamels, mediums, and modeling pastes that can be added to paint (especially acrylics and oils) to give them different consistencies and finishes. They alter the fluidity of the paint so they can become thicker, more fluid and oily, or stiffer and gelatinous. This allows you to create glazes with the addition of varnish, create impastos with modeling paste, or leave the marks of the brush on a surface by using thickening mediums.

Eggs are very important when painting with tempera. They can be used as an agglutinate or as a varnish, depending on whether you use the yolk or the white.

Organic Materials

Organic materials incorporated into a painting are not necessarily ephemeral nor does it mean they will eventually ruin the work; some have been used as agglutinates since ancient times. For example, an egg yolk can be used as glue while the egg white is a useful varnish or medium. Sugar can be mixed with water-based paint (watercolor, gouache, and acrylics) as a thickener and to make it glassy or shiny. Even wax is often added to the support to make reserves or mixed directly into the paint to make it creamier and malleable.

Sugar mixed with watercolors makes them thicker and shinier.

Varied Applications of Color

Combining and mixing different painting techniques in the same painting will affect the colors in many possible ways, making them the subject of the work, if that is the artist's intention. They acquire an essence that makes them unique and autonomous, with a graphic strength that causes them to be about the colors themselves. The greater the number of different applications of paint that you can apply to the canvas, the richer and livelier the landscape will be. For example, you could combine paint diluted with turpentine to create blended colors and speckling.

These effects can be created on wet paint, or after the layer of paint has dried so that the colors will not mix or change.

Blending creates a mixture of two colors, with the edges softened to the point of blurring.

Speckling is done by scraping your fingernail across the bristles of a toothbrush to create a spray of drops.

This oil paint is heavily diluted with turpentine. It is normally used in the first phases of making a painting.

Color can be applied while the support is still wet so it will become diluted and form blurred outlines.

Diluted Paint

Every kind of paint can be used when it is diluted, whether applied on a wet surface or by overlaying various layers of transparent colors. When working with diluted colors most of the mixing can be done directly on the canvas or on the paper if you are painting a watercolor. This is a very common technique in landscape painting because it allows you to complete the subject in a short amount of time, even if you are painting outdoors. This will result in a very luminous painting with very rich tones.

Color Backgrounds

The background color greatly influences the final appearance of a painting, and it can even affect the way you paint and apply the colors. Although it is a good idea to paint watercolors on a white surface, oils and acrylics should be painted on a dark background or base, which is traditionally used for creating chiaroscuro effects, or on a support covered with a layer of saturated color like red, orange, blue, or green, which will add some very dynamic contrasts of color. There is another option: preparing the base with a collage of colored paper that can later be integrated into the painting to create some radical contrasts.

It is a good idea to avoid the inhibiting white that we are used to painting on, and begin new chromatic explorations by using backgrounds of different colors.

If you paint over a background covered with an attractive saturated color, you should not cover it completely so that the color can be seen between the brushstrokes.

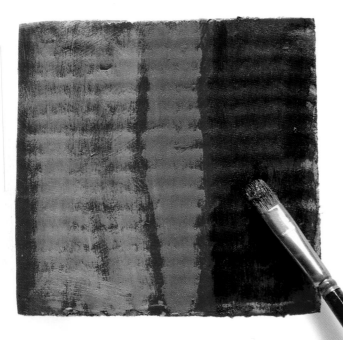

Additives and Fillers

These are inert materials that are finely crushed into modeling paste that do not add pigment to the paint and are used only to create textural effects. The fillers (sand, marble dust, carborundum, microspheres, gesso, etc.) are mixed with the paint, which makes it thicker without saturating it. It can only be manipulated with a painting knife. When the paint dries the filler becomes part of the dry paint giving the surface a bas-relief look with relief, hollows, and cracks. Here, the end justifies the means, and to create an attractive texture almost anything can be mixed with paint, mediums, varnish, and various fillers, from the finest to the thickest and most abrasive.

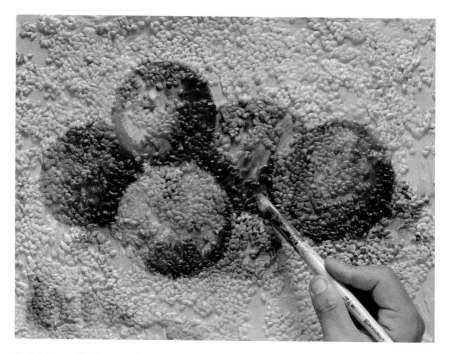

Paint is applied over a base that has been primed with heavily textured filler. In this case we have used rice.

Striated Paint with a Painting Knife

Painting knives have flexible blades that can be used as scoops. There are two basic types, the artist's spatula, which has a characteristic narrow and pointy blade, and the plasterer's painting knife, which has a trapezoidal shape, with a straight and large edge. The choice depends on the size of the painting and the application technique used. Both tools can be used to spread the creamy paste on the canvas to create striations, textures, and other marks that would be impossible to apply with a brush.

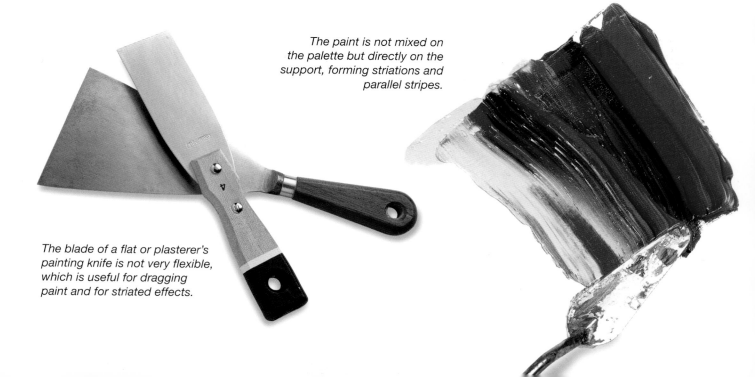

The paint is not mixed on the palette but directly on the support, forming striations and parallel stripes.

The blade of a flat or plasterer's painting knife is not very flexible, which is useful for dragging paint and for striated effects.

Incompatible Mediums: Water and Turpentine

A

Before you begin to paint it is important to remember a priori that not all mixtures are feasible because certain paints are incompatible. Such is the case of water-based paints and oil-based paints. This incompatibility extends to the mediums and derived substances that share this principle. Therefore, blending or mixing oils and acrylics or watercolors and varnish is not recommended. When these substances come into contact they repel each other and both tend to retract, forming isolated accumulations of paint that look like small puddles of color. Rather than being discouraged by this, you should embrace the opportunity to create effects that may be different and unique. You can begin by combining watercolors and turpentine on wet surfaces in different proportions to achieve broken effects, open areas of light with washes, and to create uneven accumulations of paint that contrast with the smoothness of watercolor washes.

C

B

D

A. Wet the surface of glossy paper with turpentine and paint a few lines with watercolors, which will look ragged because they will repel each other.
B. Again, wet a sheet of glossy paper with turpentine and paint over with watercolors, which will separate and expose the support.
C. Then, wet a porous paper with turpentine and paint it with a watercolor wash. The paint will not separate too much, but it will look uneven.
D. To cause a watercolor wash to separate on absorbent paper you will need to use more turpentine

Watercolors with Turpentine

The best way to compare the differences between watercolors mixed with turpentine and traditional watercolors is to carry out small tests on different types of paper (of a variety of weights and different porosity) and then try your hand at painting a simple landscape. There are two basic ways to approach it: you can wet the paper with turpentine beforehand to prevent the watercolors from sticking to the canvas too easily and end up looking too homogeneous, or submerge the brush charged with watercolor in a jar of turpentine and paint right away. This way, the brushstroke will look uneven and broken. If you puddle the paper with turpentine, the watercolor paint will separate and appear smeared, showing very attractive gaps in the color.

To create the texture of the sky, paint over a surface that has been previously wetted with turpentine using a brush with a small charge of watercolor. On the other hand, the petals on the flowers should be painted with a brush heavily charged with paint and dipped in turpentine.

Here are three basic effects with watercolors and turpentine on different types of paper:

A. On fine-grain watercolor paper painted with a medium to heavy charge of watercolor, after dipping the brush into clean turpentine. The brushstroke will be dry and striated.

B. The same approach on a sheet of Canson Figueras canvas paper for oil paint. Notice how the paint acquires more of a dotted effect.

C. You can paint with a dryer brush, but you will have to wet it with watercolors and turpentine at the same time. The texture has a stringy look and does not cover very well. In this case we have used heavy paper.

B

C

A

Effects with Diluted Paint

This is a very fast and immediate technique that allows you to create a colorful representation in just a few minutes, although it can be a difficult one to control because the paint can run and drip. The paint can be mixed with a variety of substances or be used on different supports and surfaces to achieve a variety of effects. Here, this landscape has been painted with acrylics dripping from a puddle of paint providing a very fresh and spontaneous look. We have added enamel for ceramics (which is applied cold on ceramic objects) to make the washes thicker and shinier. This is a very modern interpretation.

This is an interesting effect. Cover the surface with enamel paint for ceramics and drip acrylic paint or gouache over it. The paint separates and hardens forming areas of granulated color.

The sky has a dense blue color. When you place the support at an angle, the paint will drip and run over the landscape's background, blurring the contours of the trees.

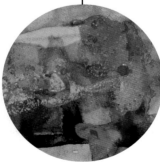

The fields of flowers on the foreground are painted with enamel, and red acrylic paint is dripped over it afterward.

The house has been drawn beforehand with a stick of wax and a black marker.

You can create interesting effects with acrylic paints. If you let the paint dry only partially and blot the rest with a rag, you will get a well-defined outline of paint and blank areas inside of it.

Dripping is one of the techniques used most often with acrylic paints. It is a very good way to paint flowers or to add strong color contrasts.

Apply very diluted acrylic paints, which will form puddles that will blend together by themselves.

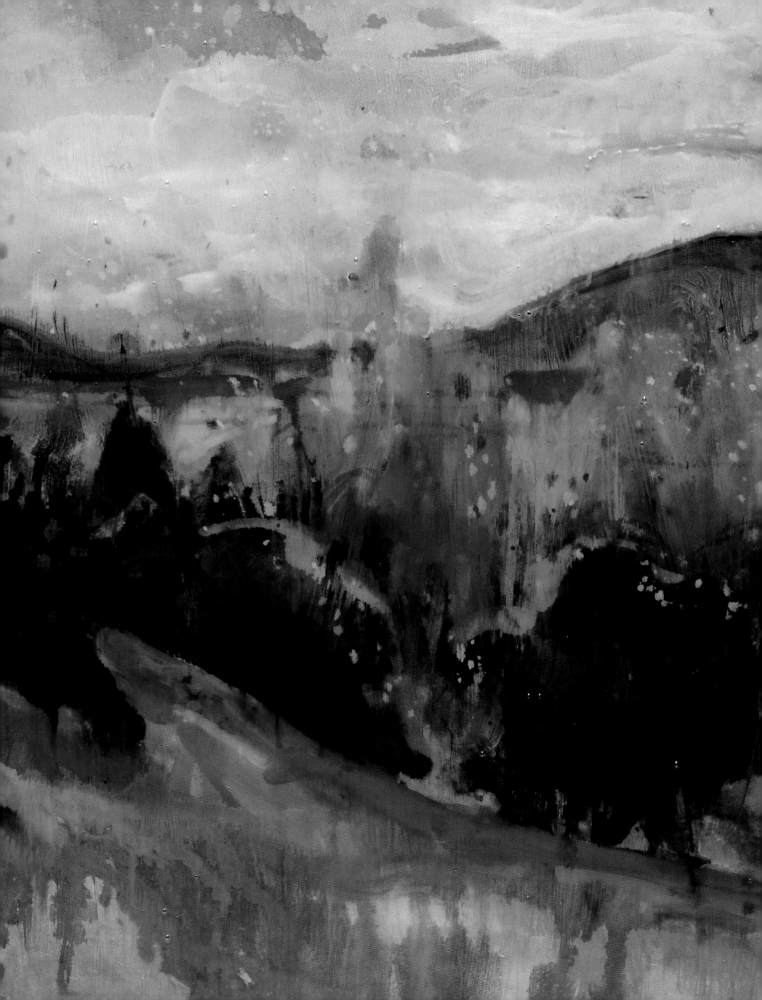

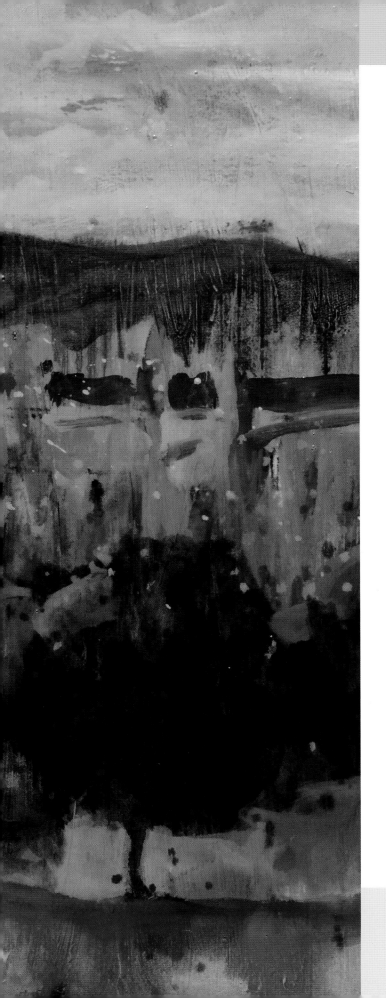

Wooded Landscape
with Diluted Oils

We begin making washes with diluted oil paints. The oil paint is dissolved with turpentine, a volatile diluent that evaporates quickly. Instead of paper, we are going to use recycled canvas. Any painting that you are not satisfied with can be a good candidate. To prepare the support cover it with a layer of white gesso, to which you will add 10 percent more latex to enhance its adherence.

DIFFICULTY	PREPARATION TIME
Low	3 hours

INGREDIENTS

- Can of latex
- Gesso
- Turpentine
- Oil paints:
 cadmium yellow
 cyan blue
 ultramarine blue
 yellow ocher
 cinnabar green
 sap green
 cadmium orange
 alizarin crimson
 burnt umber
 titanium white

UTENSILS

- Recycled canvas
 stretched on a
 frame
- Stick of charcoal
- Soft round brushes
 (thin, medium, and
 fat)
- Hair dryer

Preparation

1 Pour gesso in a glass jar and add 10
percent latex to it. Stir it with a brush and
apply it to the canvas that you wish to
recycle. It will provide a thin primed
surface ready to paint.

2 It is possible that after the gesso has
dried, the forms and colors of the
previous painting are still visible. Do not
worry, they will disappear with the first
washes.

3 Draw the landscape on the gesso surface
with a stick of charcoal. Block in the main
forms with curved lines, trying to place
each element in its precise location.

1

2

3

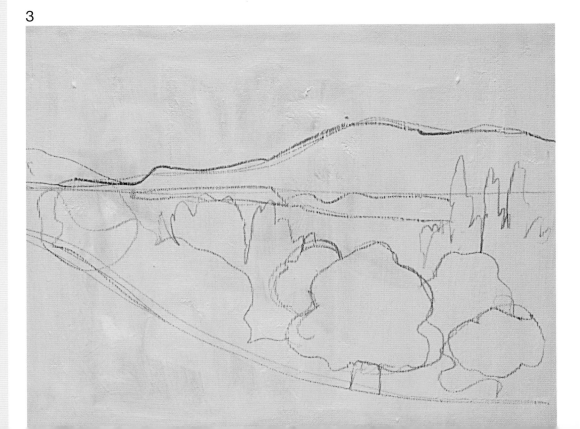

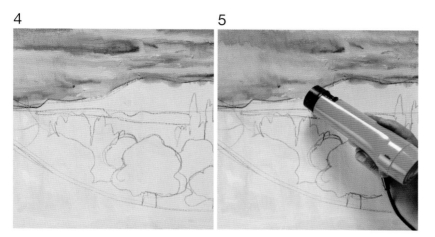

4 Paint the sky with cyan blue, ultramarine blue, titanium white, and a touch of ocher. When all the colors have been applied, tilt the support to make the washes blend together. This is done with clean turpentine.

5 When the paint is very diluted or forms puddles, a hair dryer may fulfill two purposes: to direct or mix the washes as you wish, and to speed up the drying time.

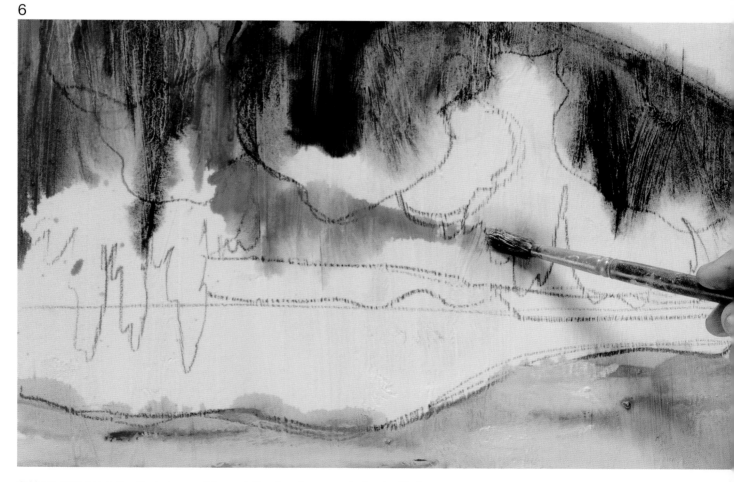

6 Up to this point, the first phase of the painting has been carried out with the support placed flat. Now, turn the painting on its top edge and tilt it to cause the green washes for the vegetation to run and drip.

7

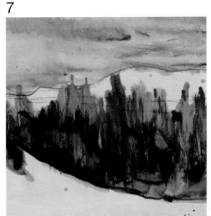

8

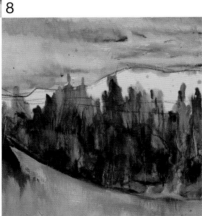

9

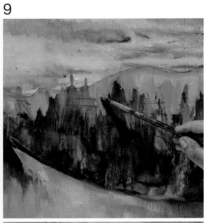

10

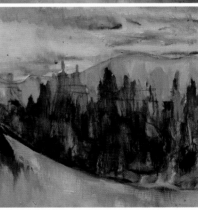

7 Place the painting flat again to prevent the washes from dripping too far and from covering the sky. The different green tones blend together following the vertical direction of the trees.

8 It is a good idea to use the hair dryer on the vegetation to evaporate most of the washes. Then, with the mixture of ocher, yellow, and orange, paint the foreground, covered with grass yellowed by the sun.

9 While the lower part of the canvas dries, cover the mountains with washes of violet color slightly tinted with blue. Add a small amount of white to make them opaque.

10 Since this wash is a bit more opaque than the others, you will be able to outline the tops of the trees better by covering the accidental drips and runs. But, it is important to keep the charcoal lines covered.

11 Dark violet made by mixing crimson and ultramarine blue will be used to paint the upper part of the mountains, while the diluted paint is still wet.

11

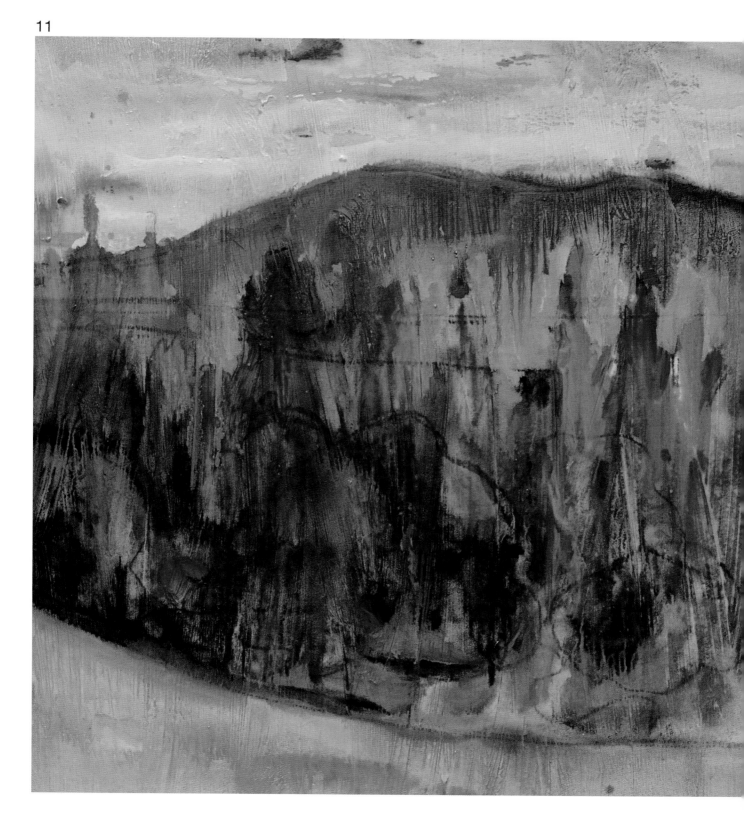

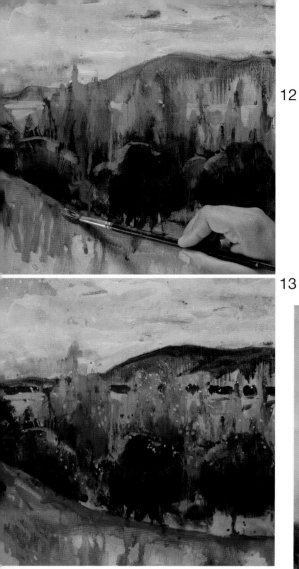

12

13

14

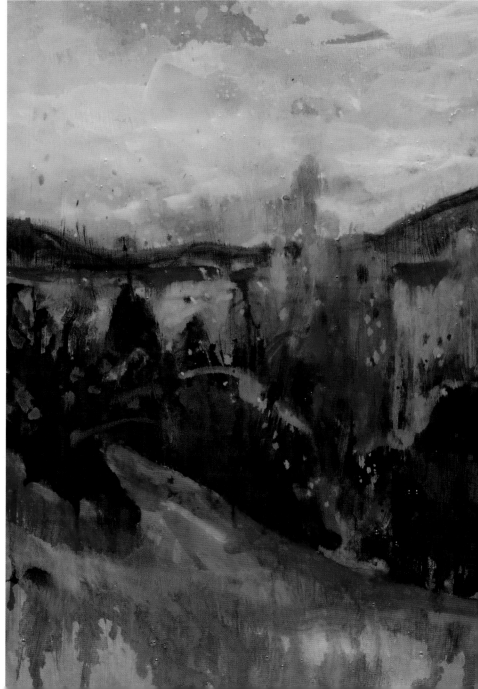

12 Paint the fields that are far away with yellow ocher. Then, work on the shapes of the closest group of trees with a mixture of sap green and burnt umber. Drip a small amount of the red wash on the foreground.

13 The yellow-green paint makes the silhouettes of the farthest lower trees stand out against nearer ones. Tilt the support slightly and let the red mix with drips of turpentine.

14 Paint diluted with turpentine usually results in a grayish color and takes away the glossiness of the paint almost completely. Therefore, once the painting has dried, apply a layer of glossy varnish over the entire surface to bring back the colors.

RECIPE CARD 1

DRIPPING

Do not worry about drips. On the contrary; if they happen spontaneously, consider incorporating them into the painting.

RECIPE CARD 2

TURPENTINE ON PAPER

Although it is not very common, oil paints mixed with turpentine can also be used on paper. The finish is very similar to watercolors.

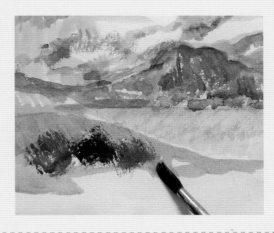

RECIPE CARD 3

DILUTING IN CONTAINERS

When you need to prepare a large volume of diluted paint, it is better to do it in containers rather than on the palette.

RECIPE CARD 4

SPLASHING

Tapping the brush charged with diluted paint against your hand will cause drops to splash on the support, which will add texture to the vegetation. This effect is known as splashing.

Glazed Finish
with Egg and Sugar

Certain natural substances, added to the paint, change its consistency. In water-based paints, such as gouache, acrylics, and watercolors, a small amount of sugar or egg white makes them thicker and shinier. Upon drying, these substances vitrify and create a hard shell of paint that makes the surface of the painting glossier. Here, we invite you to experiment with them. The model in this exercise was done with collage and mixed media.

The sugar must be white. It dissolves when mixed with watercolors and thickens the paint. It dries very hard and shiny, and has some lumps.

When you add egg white to watercolors, they become viscous and transparent. This can be interesting if you wish to apply glazes with a glossy effect.

In painting, every part of the egg is used except the shell. The yoke is used as a binder and if you mix it with powder pigment, you get tempera. The egg white acts as varnish, diluter, and vitrifying agent in water-based paints.

The egg whites are more suitable for touching up than for painting, and are good for highlighting or making the colors shiny.

Sugar, mixed with paint, is used during the painting phase to vitrify and change its consistency. The color turns darker when it dries.

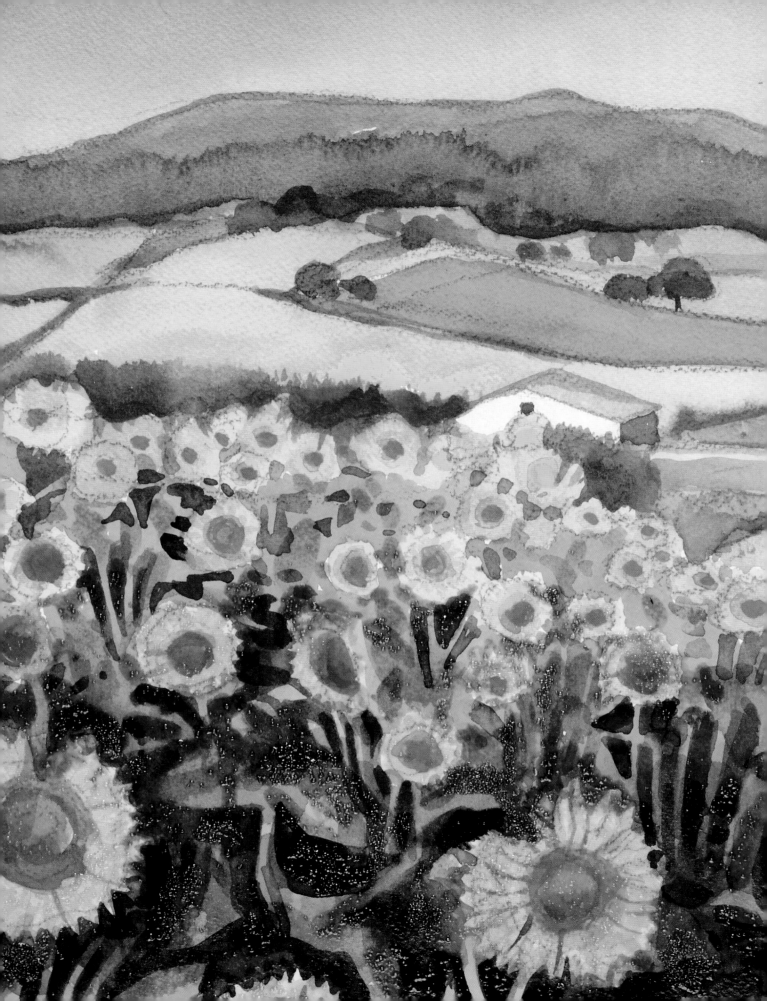

Watercolor

A Field of Sunflowers
with Washes and Glaze

Watercolor washes treated with sugar are bright and look full of light. Use them to cover each area of the landscape like a puzzle of colors. Its difficulty does not reside in the application but in the observation of the drying time for each color. In this landscape, we had to deal with two problems: on the one hand, expressing the texture and the sharpness of the foreground, which is created with sugar glazes; and on the other, painting the fields in the background very simply.

DIFFICULTY	PREPARATION TIME
Low	2 hours

INGREDIENTS

- Watercolors:
 cadmium yellow
 cobalt blue
 yellow ocher
 chromium green
 sap green
 raw sienna
 alizarin crimson
 Payne's gray
- White sugar

UTENSILS

- Medium-grain
 watercolor paper
- Blue pastel stick
- Ox-hair, round
 brushes (thin,
 medium, and fat)
- Medium, flat,
 ox-hair brush

Preparation

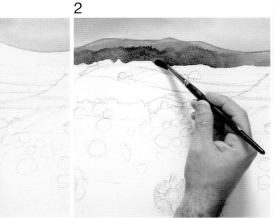

1

2

3

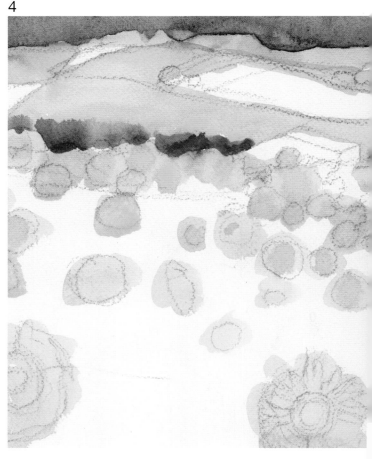

4

1 Draw the main lines of the landscape. Charge the flat brush with cobalt blue mixed with water and paint the sky. The wash should be applied more or less evenly. Let it dry before you continue.

2 Paint the mountains with an evenly applied gray-green wash. After waiting for a few seconds, add a new green at the base. When applied on a wet surface, the paint forms shapes that resemble the texture of the trees.

3 Leave some blank areas, unpainted fields, to prevent the wet washes from coming into contact with each other. With ocher, green, and yellow apply washes to the fields of the middle ground.

4 While the washes of the fields dry, paint the flowers with very diluted yellow, which is combined with applications of more saturated yellow for the flowers on the second plane.

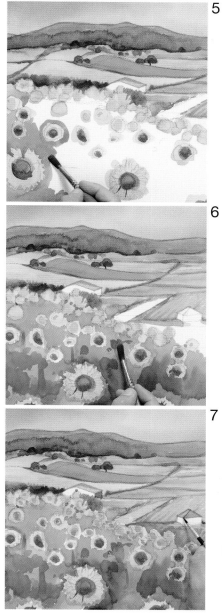

5

6

7

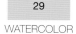

Advice

Whenever you add a new wash you should make sure that the paint in the adjacent areas is completely dry. This will prevent accidental mixtures.

5 Paint the fields green with light and diluted washes. The trees look like simple splashes of color painted with the thin brush. Darken the central part of the sunflowers in the foreground with raw sienna and medium green. With the same green and the medium brush cover the rest of the paper to create a base over which you can paint later.

6 Apply new areas of emerald green over the previous green base. On the lower part of the paper these greens accumulate in a scattered manner. The shapes of the closest flowers should look jagged.

7 Paint a few details in the middle ground with the thin brush: the roofs and the facades of the little houses, the sides of the road, and the lines of the fields.

8

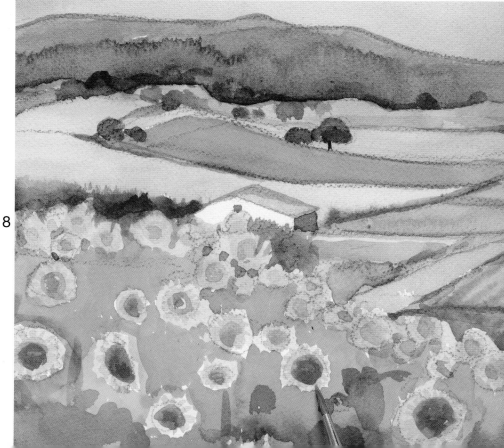

8 Add a few touches of orange yellow on the corollas of the closest flowers. Do not cover the entire flower, only the specific area.

9 Finish the house on the right with two new ocher colors of different intensity. With medium green paint the central circle of the sunflowers in the middle ground.

10 The shaded areas in the foreground are painted with a thin brush. Dark-green paint contrasts and defines some of the stems and flowers.

11 Dilute a small amount of sugar in water on the watercolor palette. The result is a caramelized mixture that is added to the yellow paint to add the last touches on the flowers.

12 Repeat the process, although this time the permanent green watercolor and a touch of burnt umber are added to the sugar. Again, apply a few brushstrokes over the mass of vegetation. When the sugar dries, the glossiness becomes a little more satiny.

9

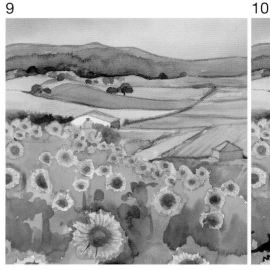

10

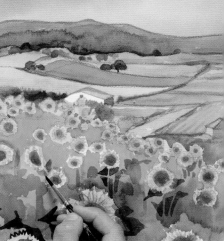

12

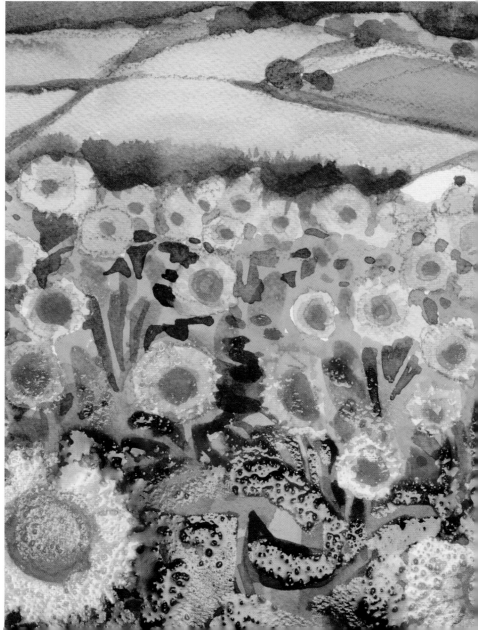

11

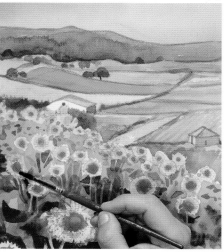

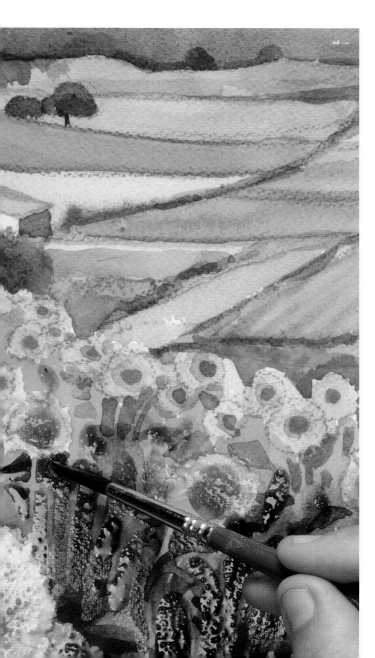

RECIPE CARD 1

NEGATIVE PAINTING

Negative painting means painting the area around the object instead of the inside of the object; this way the lines look sharper and better defined.

RECIPE CARD 2

EACH PLANE A DIFFERENT COLOR

The easiest way to tackle little houses is to paint each side with a different color, as if it were a simple geometric figure.

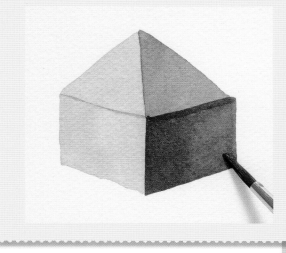

Reserves with White Wax

Given the incompatibility between wax and watercolors, wax is often used to create reserves, or to add texture to watercolors as well. It becomes an interesting alternative for masking fluid with the added advantage that it provides greater artistic possibilities. Let us see a few examples, in which we will use white candle wax and oil pastels.

A stick of white oil pastel can be used to make heavy lines on paper. It is often used to reserve white areas before beginning to paint.

Rubbing a medium-grain paper with a white candle exposes the grain. This becomes more evident after a wash has been applied.

The candle can also be used hot or even melted; for example, you can let the melted wax from a lighted candle drip to create dotted reserves.

The surface looks white and granulated, the result of rubbing a white wax candle repeatedly over the entire surface.

To create the sun, paint the area with a brush and melted wax.

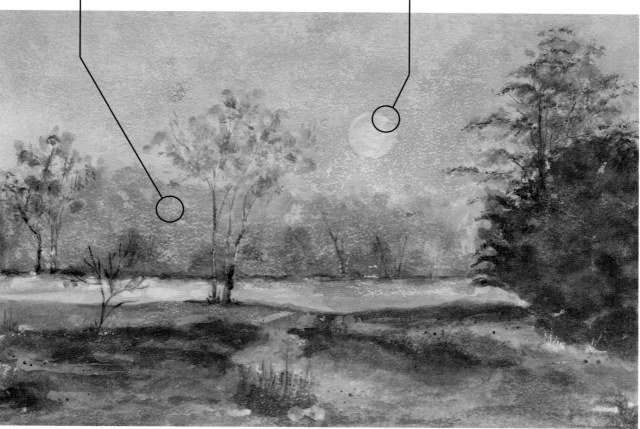

You can also pick up the melted wax from the candle with a bristle brush and apply it immediately on the paper.

To get melted wax let a candle burn for a while, then, with a bristle brush pick up the melted wax from around the base of the flame, and spread it on the painting.

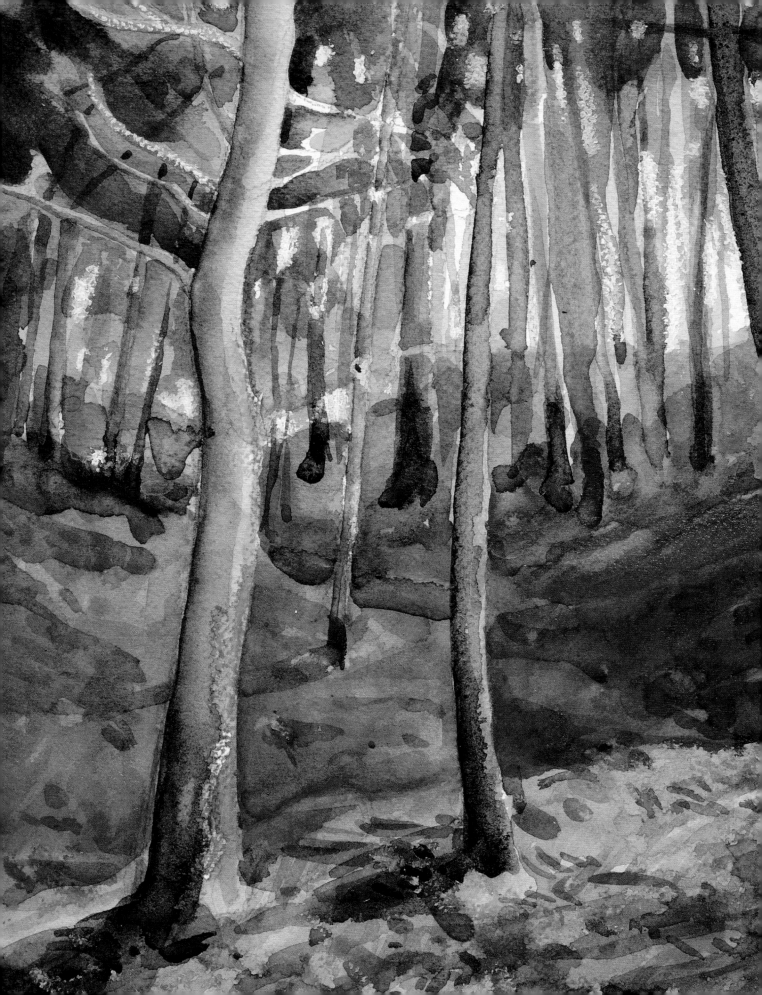

Recipe 3

Watercolor

A Forest
with Reserves

This forest has been painted with watercolors, using a limited range of colors (greens and browns) and with a naturalist and realist style. This exercise, which makes restricted use of colors, is an interesting opportunity to pay more attention to tonal contrasts. The darkest areas have been painted with violet and burnt umber applied to the local colors. The exercise is completed with the addition of reserves made with oil pastels or wax crayons, which are very useful to reserve reflections and highlights, or to paint the texture of vegetation.

DIFFICULTY	PREPARATION TIME
Medium	3 hours

INGREDIENTS

- Watercolors:
 cadmium yellow
 yellow ocher
 chromium green
 sap green
 emerald green
 raw sienna
 burnt umber
 alizarin crimson
 Payne's gray
 cobalt blue

UTENSILS

- Medium-grain
 watercolor paper
- HB graphite pencil
- Oil pastels
- Round, soft brushes
 (thin, medium, and
 fat)

Preparation

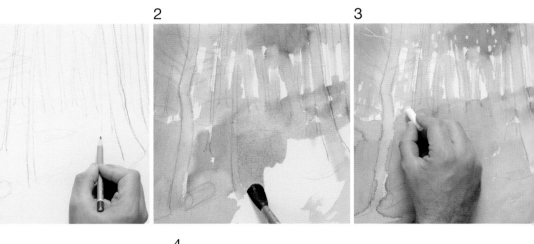

1

2

3

1 With a graphite pencil draw the closest trees in detail. The ones in the background should look less defined so they are drawn with a couple of parallel lines.

2 Cover most of the paper's surface with very diluted and mixed emerald green, sienna, and raw umber. The idea is to work progressively with glazes working from less to more.

3 To prevent the areas of light in the background from smearing accidentally, cover them with a few touches of oil pastel. Remember that these lines will repel water-based paint.

4 Cover the background of the forest with a mixture (as you progress and while still wet) of sienna, sap green, and a small amount of yellow. The colors will blend together.

4

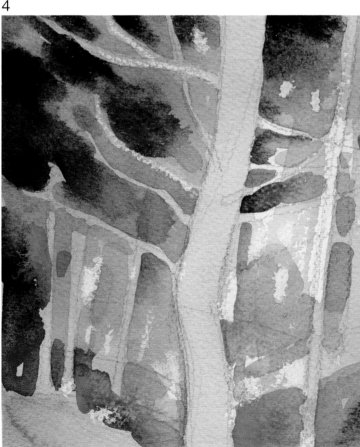

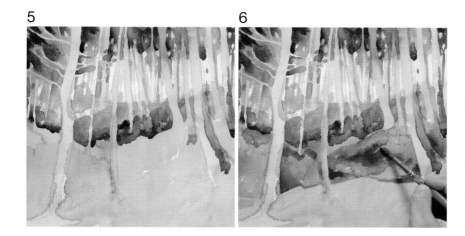

5 With single brushstrokes paint the vegetation in the background, which has different shades of greens and browns. Work with the tip of the brush to avoid touching the tree trunks and the white of the background.

6 Do the same on the middle ground with ocher, sienna, and burnt umber. All the mixtures should be made on a wet surface so the colors can blend together.

7 Paint the texture of the foliage in the foreground with short and quick strokes of green and yellow. The grainy texture of the paper will enhance the broken and spontaneous lines.

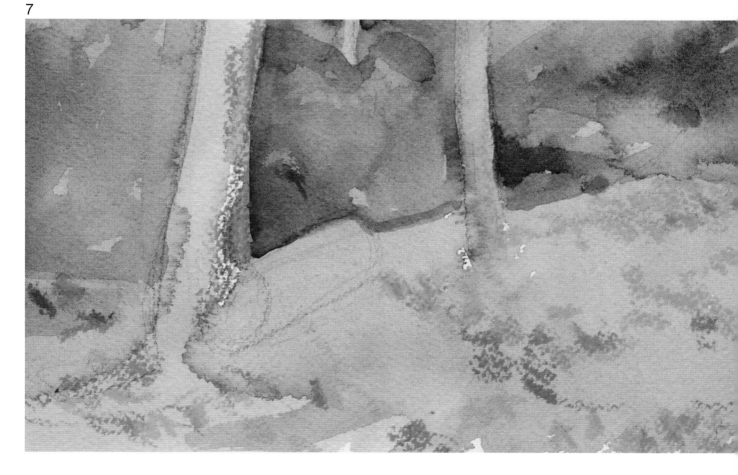

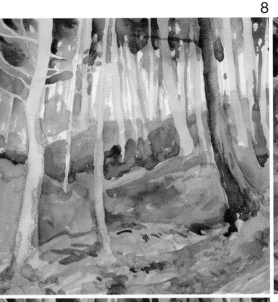

8

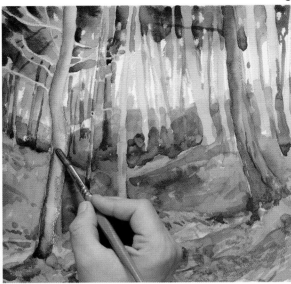

9

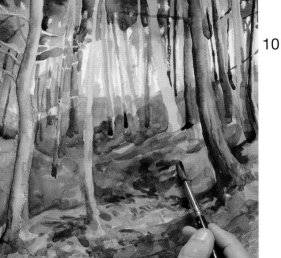

10

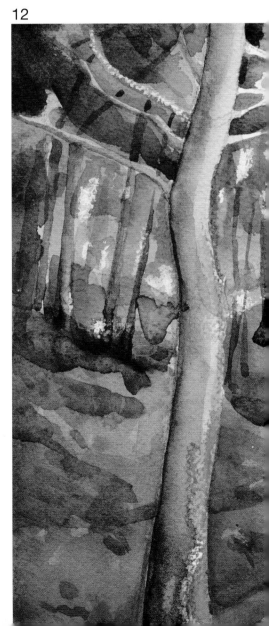

12

11

8 Mix burnt umber with violet to apply the first washes on the lower part of the paper. Use the same color to darken the tree trunk on the right.

9 Now it is time to focus on the tree trunks. Paint the moss on them with short brushstrokes. Then, continue painting with burnt umber diluted with a large amount of water to form a gradation.

10 Paint the trunks in the distance with blue gray, making them darker at the base. Continue in the middle section with burnt umber. At this point the idea is to darken the watercolor by layering glazes.

11 Continue darkening the trunks with Payne's gray, and while the paint is still wet, apply dark gray with a thin brush to the base of every one of them.

12 Let the paint dry for a few minutes. Cover the entire middle plane with a sienna wash. This will form a simple glaze that will give this area more warmth.

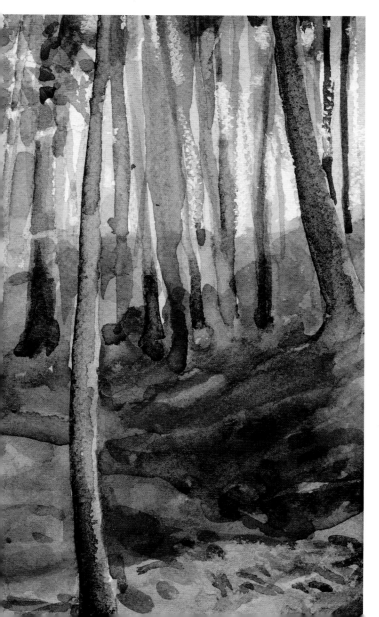

Suggestions

RECIPE CARD 1

CHECKING THE COLOR

Before you apply the paint, check the color on a piece of scrap paper to make sure that it is the intended one.

RECIPE CARD 2

PAINTING BY ZONES

One way of making better progress with watercolors is to paint by zones. Cover spaces that are not adjacent to each other to prevent two washes that are still wet from touching each other.

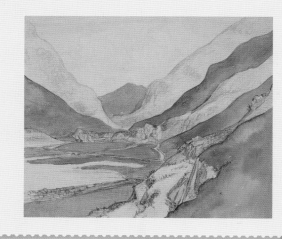

Varnish. From Transparent to Glossy

Traditionally, varnish has been associated with painting finishes, but it does not have to be that way. Its gloss and transparency qualify it as a medium in its own right, and because of its oily consistency it can be mixed with oil paints easily, whether to change the consistency of the paint, to create transparencies, or to change the color of a painted surface. Some artists mix it with pigment to create puddle effects; it allows them to treat the color surface in a variety of ways.

Varnish has a resinous consistency. It is transparent, although you can get better results with the translucent variety, which has a characteristic tea color.

The varnish acts as an agglutinate when you dust it with pure pigment. The result has a mottled look.

It maintains its transparency even when dyed with any color. It can run when applied over surfaces that are placed at an angle, but it can be controlled easily because it is very dense.

This effect is achieved by dusting violet pigment over areas of Holland varnish that are still wet.

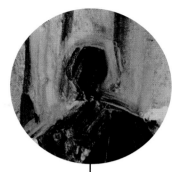

The silhouettes of the figures show greater contrast when they are covered with a thin layer of varnish. This gives the colors more intensity.

If you cover the oil surface while it is still wet, with a layer of varnish, the forms appear slightly blurry and out of focus.

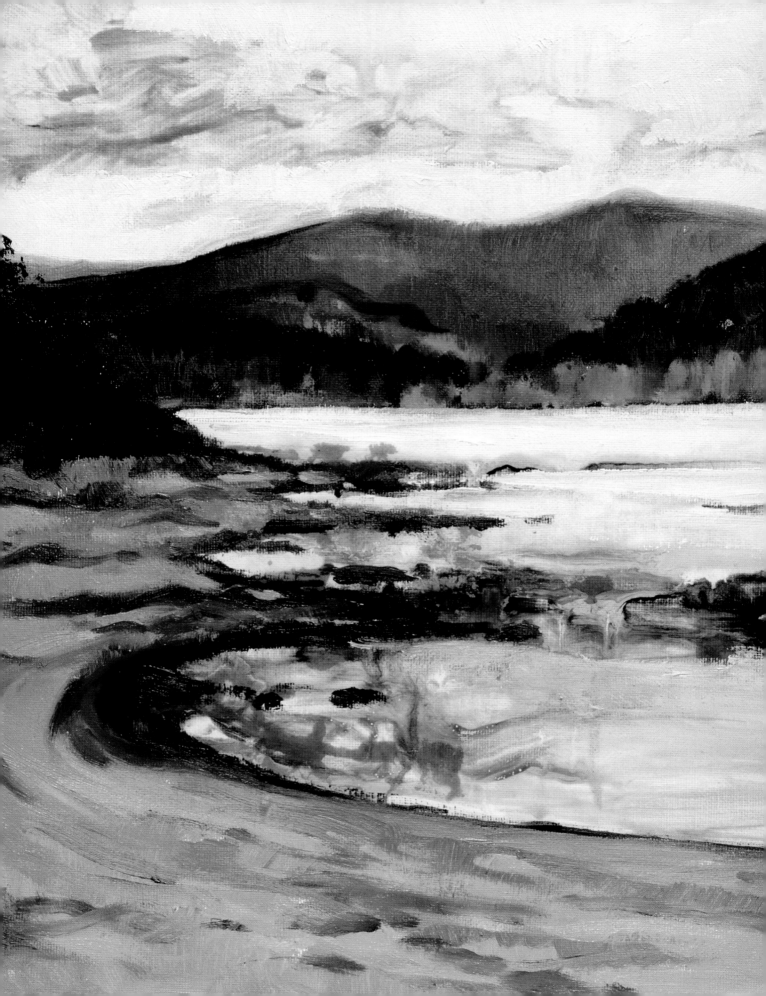

Oil
Landscape
with Varnishes

*O*il paints combined with varnish become shinier and more transparent. In this exercise, varnish is used to enhance the fluidity and transparency of the water, as well as the dim clouds that cover the sky. The combination of the opacity of oil paints and the thick and fluid consistency of varnishes makes it possible to apply a treatment that will help describe the surface and add greater visual variety to the painting.

DIFFICULTY	PREPARATION TIME
High	7 hours

INGREDIENTS

- Oil paints:
 burnt umber
 mixed green
 cadmium orange
 yellow ocher
 cobalt blue
 cobalt violet
 burnt sienna
 magenta
 ivory black
 Naples yellow
 titan white
- Transparent varnish
- Synthetic dark
 varnish for wood
- Yellow enamel paint

UTENSILS

- Canvas
- HB graphite pencil
- Bristle filbert
 brushes (thin,
 medium, and fat)

Preparation

1

2

3

4

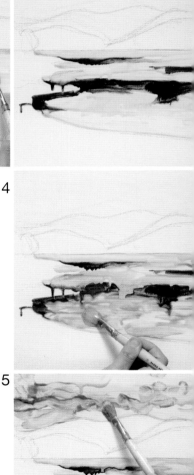

5

1 First, make a very simple drawing that will serve as a guide when you begin to paint.

2 Pour a small amount of transparent varnish in a small container and tint it with a touch of cobalt blue. It should be a minute amount so as not to affect the transparency of the varnish. Paint the surface of the water with the mixture.

3 Over the transparent varnish base apply a few brushstrokes with the dark varnish for wood.

4 Mix both varnishes while you are applying them and tilt the support to cause it to drip.

5 Paint the sky with the previous blue varnish mixture. Try to define the forms and distribution of the clouds while you paint. Then, charge the brush with a large amount of transparent varnish and spread it generously.

6 Apply new brushstrokes of transparent varnish to create some highlights and to suggest the effects of the sky. Use the transparent varnish to soften the contrast of the dark varnish on the water.

Advice

When you add varnish to oils, the resulting paint will be creamier and thicker. It acts as a medium and makes it more fluid.

6

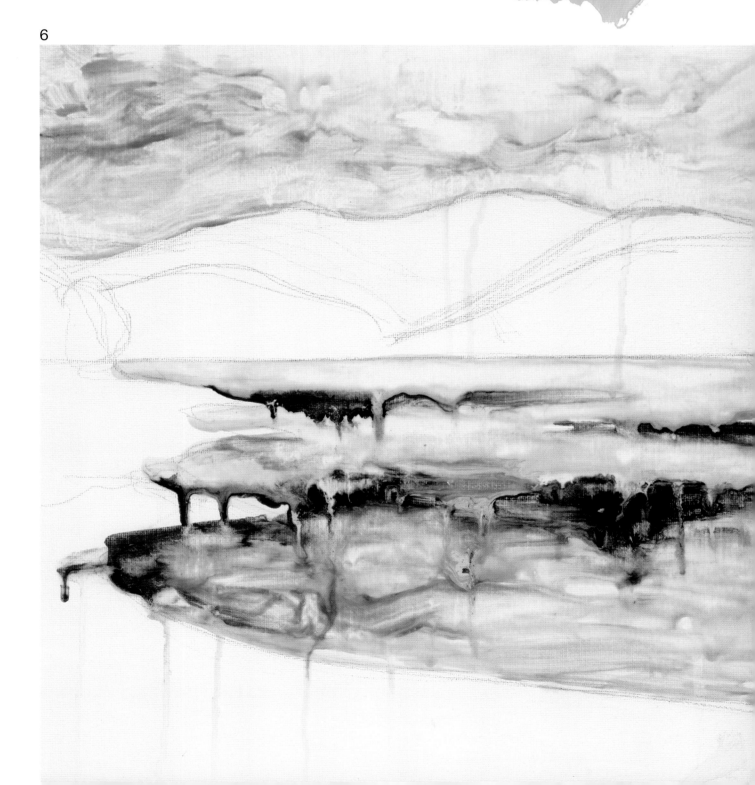

7

8

Advice

The varnish should be thick at all times. Avoid diluting it with turpentine because it could lose consistency and its ability to adhere to the support.

7 While the varnish is still wet, pour a few drops of enamel on the water surface. These two substances are incompatible and combining them causes the drops to concentrate without blending.

8 After applying the enamel, the use of the varnishes, which were restricted to the sky and the water of the lake, is completed. Let the layer of varnish dry for two hours.

9 Resume painting with oils by lightening the clouds in the sky with titian white. The goal now is to define the work that was done with the varnishes.

9

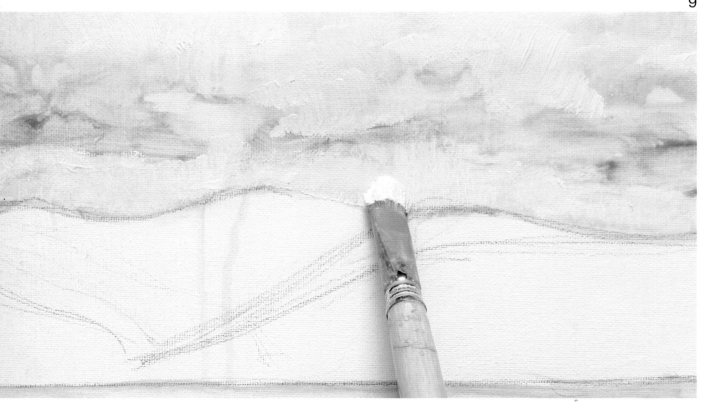

10

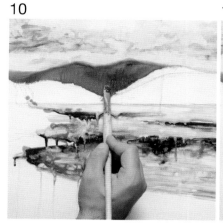

11

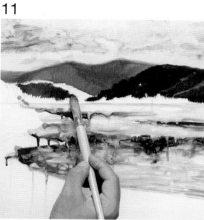

10 Paint the most distant areas with violet that has been somewhat lightened with white to create the effect of distance. Blur the outlines of the mountains with the brush.

11 As the mountains get closer to the lake darken their color by adding burnt umber to a blue base.

12 In this phase, paint the nearest areas with burnt umber, cobalt blue, and burnt sienna. These colors should be applied thickly and mixed with each other.

12

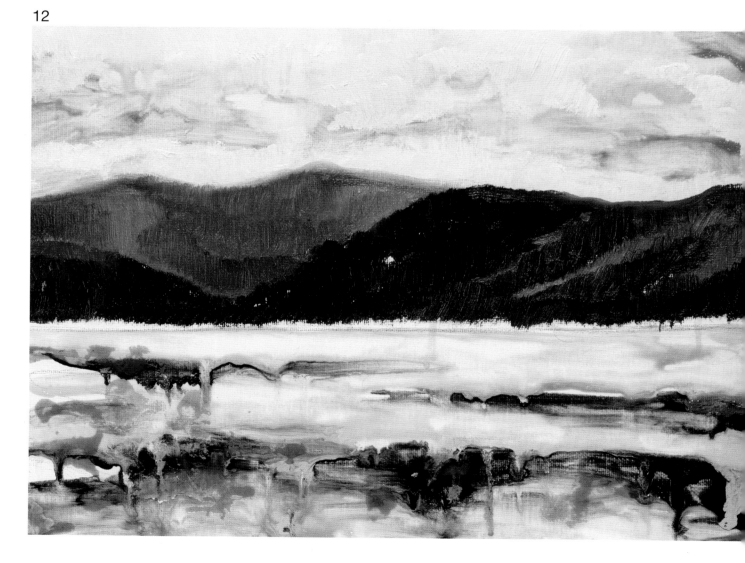

13 **14** **15**

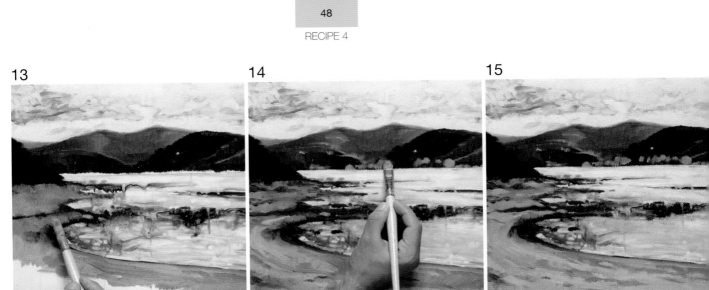

13 Paint the sand on the shore of the lake with ocher mixed with white and a touch of Naples yellow. Use black mixed with burnt umber to paint the trees that appear on the left side.

14 With a thin brush work in the texture of the sand with horizontal strokes, on a wet surface, which will create the different brown tones. Paint the first green applications on the areas of the vegetation on the opposite bank of the lake and at the foot of the mountains.

15 Touch up the surface of the water with white mixed with a small amount of blue, to fix some of the varnish drips. Lighten the sand with a few brushstrokes of ocher with a little more yellow in it.

16 Complete the vegetation in the background by combining different bright and saturated greens with orange and red-violet colors. A few brushstrokes of dark green are added moving up the mountainside to suggest relief.

Suggestions

RECIPE CARD 1

BETWEEN ENAMEL AND VARNISH

When enamel is repelled by varnish it forms an interesting mottled effect.

RECIPE CARD 2

VARNISH AS MEDIUM

Oil paints can be diluted with Holland varnish or finishing varnish to create thin, translucent glazes.

16

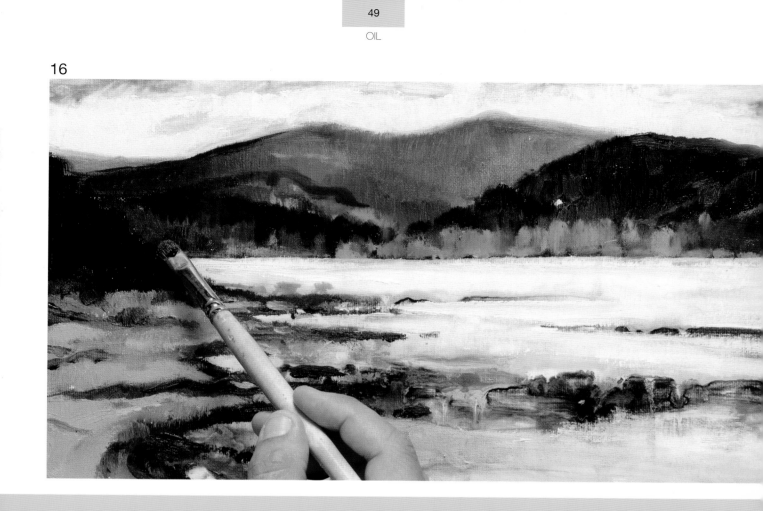

RECIPE CARD 3

INTENSIFYING COLORS

*Varnish intensifies the colors.
See the difference in color between
the area with the varnish and the
one without.*

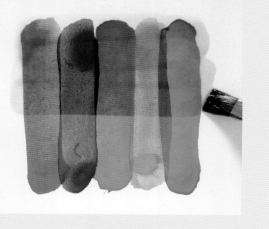

RECIPE CARD 4

PAINTING ON WET

*To create a blurred line, simply
paint over a layer of wet varnish.
Notice the difference between painting
on dry and painting on wet.*

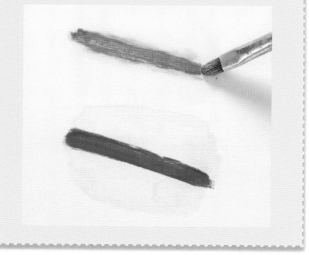

Experimenting with Different Color and Gesso Backgrounds

Cover the support with gesso to conceal the grain completely and color it with paint mixed with turpentine and varnish. The brush will slide easily over this surface.

Many artists tend to ignore the background and not to give it the importance that it deserves. However, painting over backgrounds that have different color combinations can turn an ordinary subject into a piece with a personal touch and greater impact, which can inspire a creative representation. This forest scene has been painted over a red background. The artist has given free rein to his or her imagination and has used imaginative and saturated colors.

The bases treated with gesso make painting with turpentine easier. Since it has some relief, the paint spreads unevenly over the background giving it an attractive appearance.

Oil paints can be used on any surface, even on one with coarse texture, such as the ridges of cardboard.

The prepared background may itself look like an abstract painting. This one has been made with cutouts of brown wrapping paper.

The tops of the trees have been painted in negative. The blue represents the sky while the unpainted red background represents the leaves and the tree trunks.

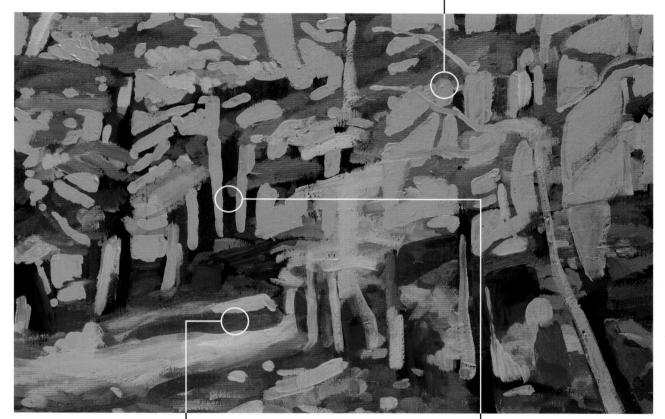

To maximize the colors we have disregarded the more subtle tones and have worked with oil paints that were saturated and not overly mixed.

Each brushstroke should be different from adjacent ones to achieve greater expressiveness and richness of color.

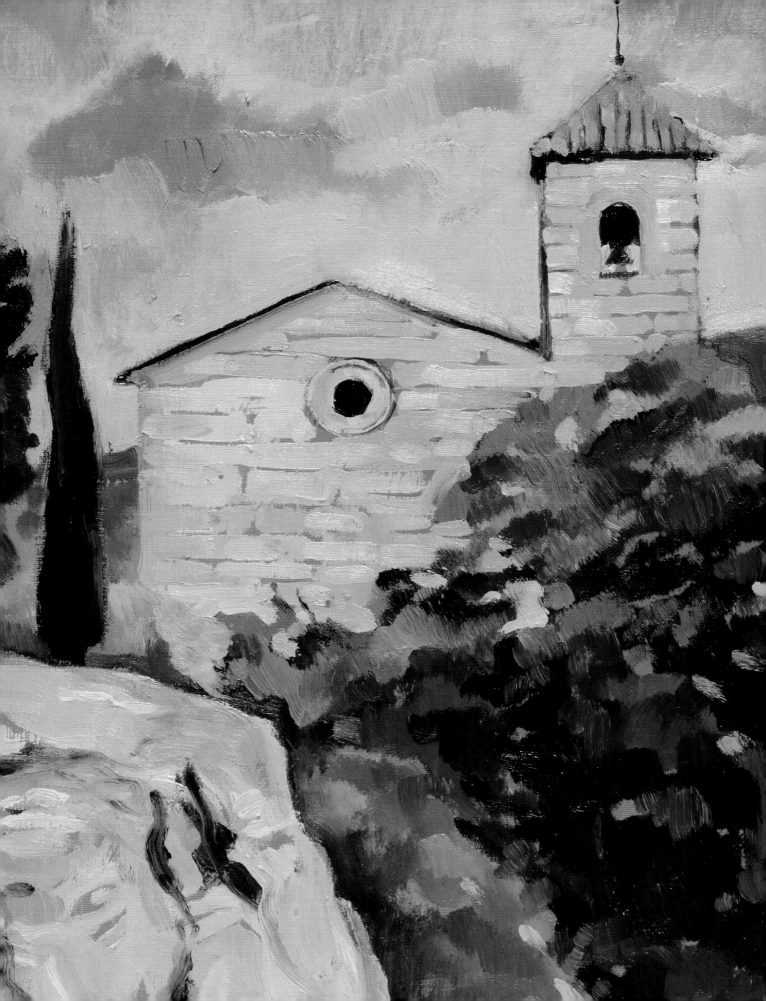

Oil and Acrylic

Landscape with a Small Church:
The Anticerne Effect

T his landscape gives you the opportunity to experiment with different surfaces: vegetation, rocks, stone walls, and sky. Each one requires a different brushstroke. The entire landscape is subject to the *anticerne* effect, a way of painting that lets the background show through between the brushstrokes to become an integral part of the work. To enhance the effect, paint the background with a very saturated and garish color that maximizes the contrast; this way the colors will stand out even more and will create a very expressive effect.

DIFFICULTY	PREPARATION TIME
LOW	3 hours

INGREDIENTS

- Orange acrylic paint
- Can with turpentine
- Oil paints:
 cadmium yellow,
 cyan blue,
 ultramarine blue,
 yellow ocher
 cinnabar green
 mixed green
 emerald green
 sap green
 alizarin crimson,
 burnt umber
 titanium white
 ivory black

UTENSILS

- Canvas board
- Blue wax crayon
- Hog-bristle filbert
 brushes (thin,
 medium, and thick)

Preparation

1 Apply an even layer of orange acrylic paint over the entire support. The paint should be creamy, not overly diluted, to achieve maximum saturation.

2 Let the acrylic paint dry. Then, with a blue wax crayon or oily pastel stick do a line drawing of the subject. Begin with very soft lines, almost imperceptible, then go over them with more defined lines.

3 The rest of the exercise is done with oils. Create the sky with opaque colors, painting juxtaposed areas with different shades of blue mixed with white. Outline the profile of the mountains with the brushstrokes but leave some areas of the sky unpainted.

4 Superimposing areas of blue creates tonal gradations, with the darkest blues located on the upper part of the sky. In this case we add a touch of ocher or carmine to break up some of the blue areas.

1

2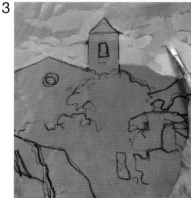

3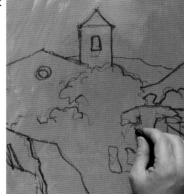

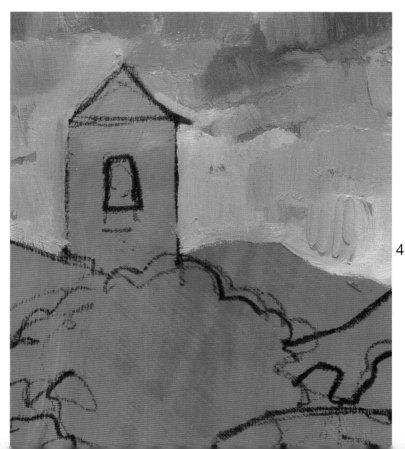

4

Advice

The anticerne effect will look more vivid if the oil colors are also vivid. The goal is to convey vitality and energy

5 The colors of the mountains in the background are an extension of the colors of the sky, although the blue is more vivid and intense. We left the outline of the mountains unpainted to expose the orange line.

5

6

6 Once the background is completed continue with the trees. Using mixed green, emerald green, and sap green, all combined with some yellow, creates a variety of shades that can be superimposed from lighter to darker.

7 Mix sap green with raw umber to create the dark greens to paint the cypress tree and the most shaded areas of the trees. Apply the brushstrokes with an upward motion, like the rest of the vegetation.

7

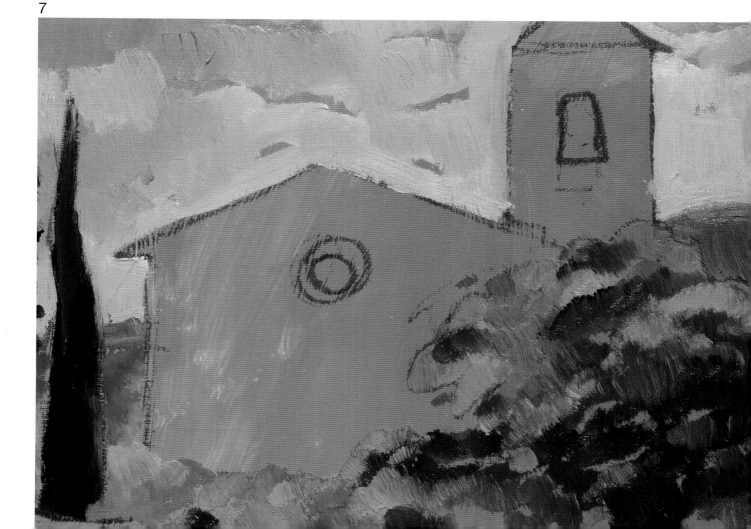

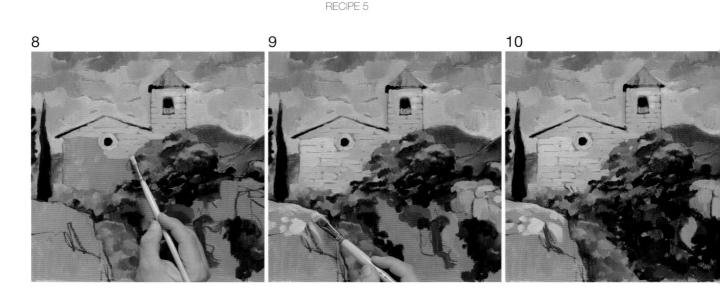

8 9 10

8 It is better not to work by area but rather to approach the painting as a whole, working all the parts simultaneously. To paint the stone facade of the church, reserve a space that can be left as a series of lines to describe the placement of the stone blocks.

9 Finish the bottom of the facade with ocher mixed with a greater amount of white. Next, paint the rocks in the foreground with a variety of blue grays and violet tones mixed with white. Leave the nooks and crannies unpainted.

10 Now return to the vegetation. The superimposed areas of sap green and emerald green, tinted with ocher and burnt umber, are used to finish covering the lower part of the canvas.

11 Leave the lighter colors for the end. Make small additions on the facade of the church, over the rocks, and with larger strokes over the still-wet sky to create chromatic homogeneity.

Suggestions

RECIPE CARD 1

BACKGROUND COLOR

Select the color for the background according to the colors of the model. If you plan to use warm colors, the best option is green.

RECIPE CARD 2

CHOOSING COMPLEMENTARY COLORS

If the predominant colors are going to be green or blue, the best option is a red background.

11

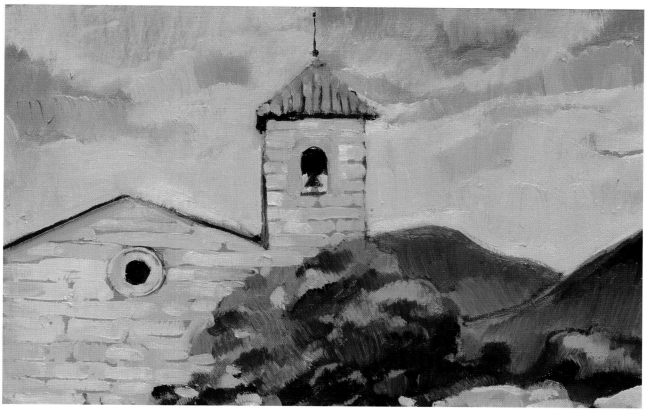

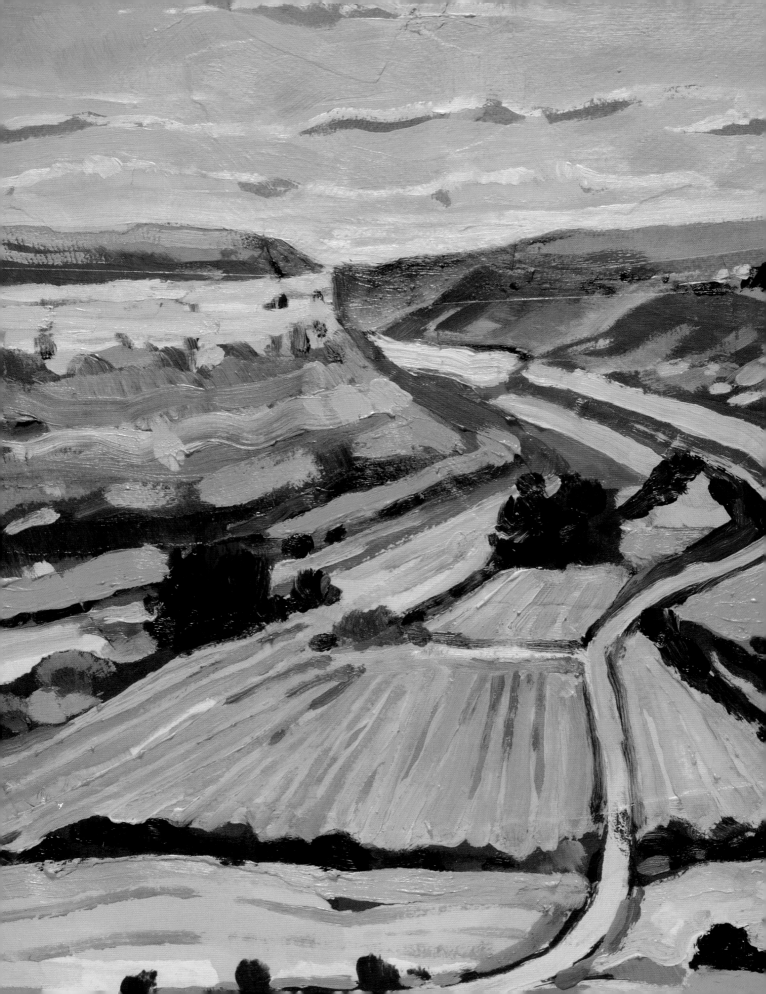

Landscape
with Collage and Oil

Oil painting combined with other techniques produces a more modern and colorist interpretation with a more vibrant finish than a traditional or naturalistic interpretation. The white canvas can be covered with a large number of color cutouts, which will provide a base that will have an effect on the range of colors and the finish of the painting. You only need to learn the technique and put it to good use.

DIFFICULTY	PREPARATION TIME
Medium	5 hours

INGREDIENTS

- Transparent matte varnish
- Oil paints:
 burnt umber
 cobalt violet
 cyan blue
 ultramarine blue
 magenta
 cadmium yellow
 cadmium orange
 cadmium red
 mixed green
 emerald green
 yellow ocher
 burnt sienna
 white
- Latex
- Paper cutouts of various colors

UTENSILS

- Stretched canvas
- Charcoal stick
- Filbert brushes (thin, medium, and thick)
- Thick round brush
- Cotton rag

Preparation

1

2

3

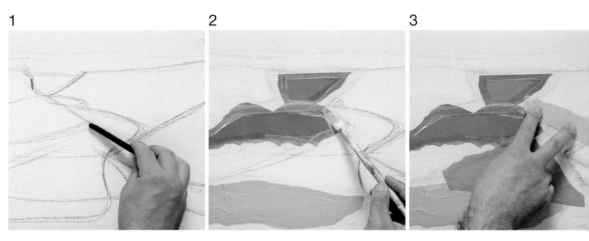

4

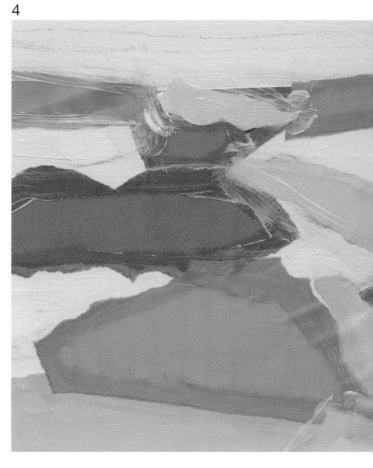

1 Lay out the main lines of the landscape with the tip of the charcoal stick. The lines should be very light to prevent the canvas from being stained with the charcoal dust.

2 Tear pieces of different color papers by hand and glue them to the support with thick latex. Do not add water or the papers will swell or warp.

3 Apply a layer of latex over the canvas with the thick round brush, applying light pressure on the pieces of paper. Choose a variety of bright colors, which do not have to relate closely to the real model.

4 After you finish gluing the paper on the support, paint the edges as well with the latex to ensure a good bond. Press with the tip of the brush to prevent any of the sides from coming unglued.

5

6

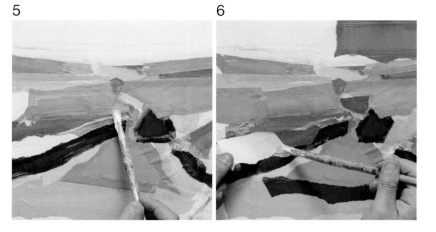

7

Advice

It is better to tear the papers by hand than to cut them with scissors. That way the outlines will have a more jagged and casual look, less linear and geometric.

5 First, cover the white spaces, but as you continue working, some papers can begin to partially overlap each other.

6 The goal is not to leave any areas uncovered. The papers should be progressively smaller. The latex, when it dries, becomes completely transparent.

7 Now the collage is finished. This is the color background over which you will begin to paint. The color arrangement should have some relationship with the main forms and lines of the landscape.

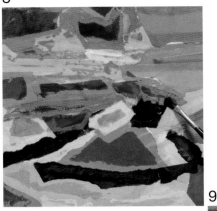

8 When the glue is completely dry, dip the brush into transparent varnish and cover the color surface with it to soak the paper and make it hard.

9 Let it rest for a few minutes so the papers can absorb the varnish, then, blot the rest with a clean rag to prevent puddles from forming on the canvas.

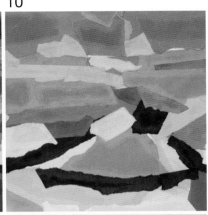

10 Allow the varnish to dry for an hour and a half and for the surface of the painting to become stiffer; after that, the papers will be smoother and harder, less porous. After drying, the dark streaks on the papers will become lighter.

11 Begin to paint the sky with cyan blue mixed with white. Leave some areas unpainted, that will represent the clouds. With the same blue, outline the upper contours of the mountains.

12 The next areas painted with oils mixed with a small amount of mineral spirits will be applied on the terrain. Try to correlate the colors of the collage with the features of the landscape.

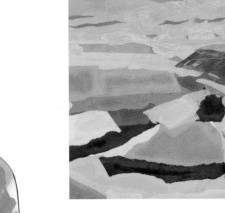

Advice

It is best not to cover the underlying color papers with too much oil paint so you will not lose their texture.

13

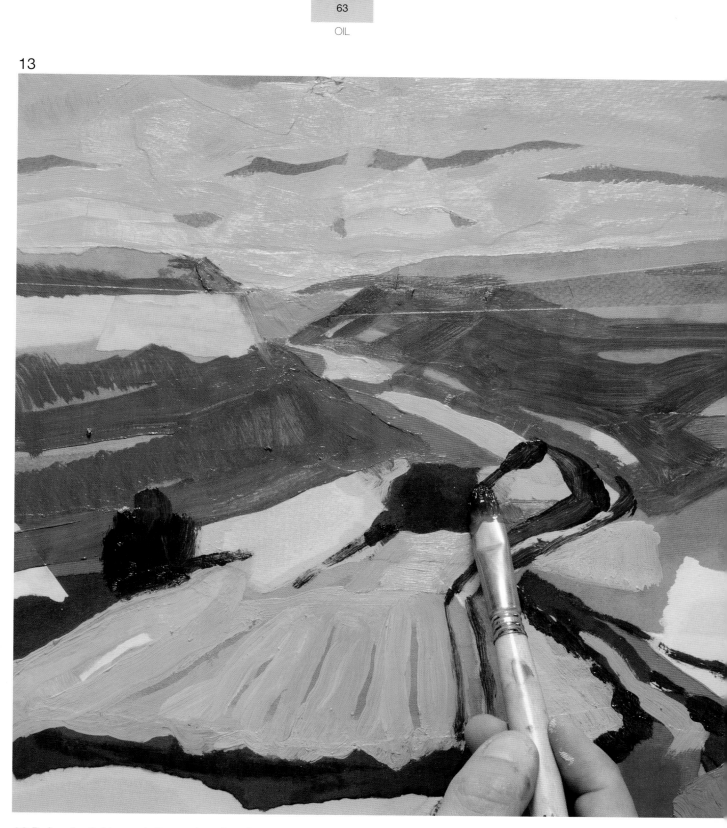

13 Define the fields, mark the road, and outline the contours of the hills using thick brushstrokes and different shades of green. As the work progresses a thinner brush should be used.

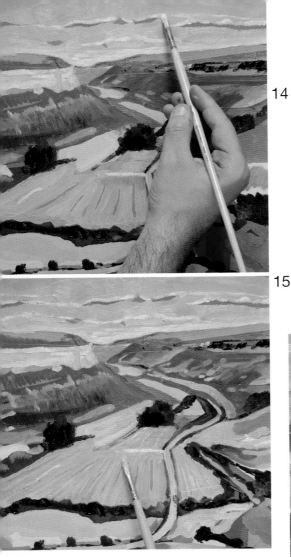

14

15

14 Paint the illuminated areas of the clouds with a simple white outline. The different planes of the painting will begin to appear as new strokes of color are added.

15 Using a thinner brush define the cultivated fields with a series of diagonal lines. The color of the paper underneath should be visible in between the yellow lines.

16

16 Leave the thicker and heavier brushstrokes for the end. They should follow the surface of the terrain. We are using very saturated colors, which gives the landscape a very colorist effect.

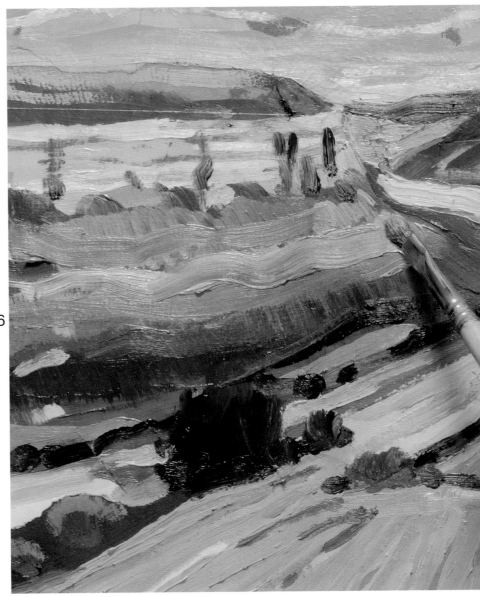

RECIPE CARD 1

OVERLAYING

While the varnish is still wet you can layer oil paint diluted with turpentine over it. Wait a few minutes so the color is absorbed, and then blot the surface with a cotton rag.

RECIPE CARD 2

THE PAPER

It is important to have an assortment of papers. The colors should be very saturated and contrasting. Do not be afraid to work with bright colors.

RECIPE CARD 3

TRANSPARENCIES

You can also create glazed lines or expose the lines underneath through transparencies. After you make the drawing, place the paper over it. Then, cover it with varnish and the drawing will subtly reappear.

RECIPE CARD 4

WITHOUT A FRAME

After you finish the main subject, extend the paint around the sides of the canvas so both areas will form a continuous surface. This is a very common practice among contemporary artists; you can hang the painting without a frame. If you prefer, you can use a box-style frame.

Suggestions

Experimenting with Fillers

Experimenting with gesso, marble dust, gels, and latex will give you additional resources that can be used to develop creative textures that can be incorporated into the painting. The supports prepared with textures provide greater visual interest to the work and can be combined with oil paints or with acrylic paints, or with both at the same time.

The mixture of rough marble dust and latex provides a very textured and abrasive base that produces a strong visual effect.

There is no need to be satisfied with marble dust, you can experiment with many other interesting materials that can create different surfaces, for example, sand, carborundum, and sawdust.

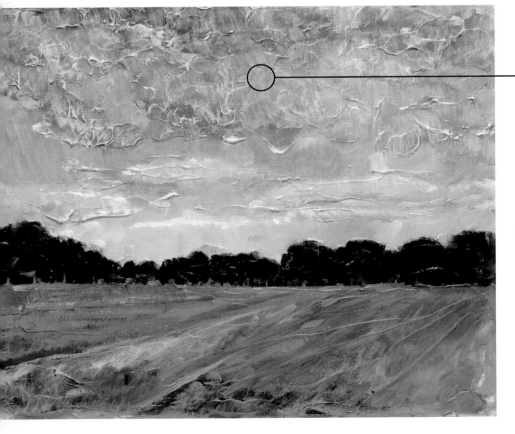

Acrylic gel is a type of paint with a polymer base that can be used to add texture to a surface that is going to be painted with oils. The relief that it creates is smooth rather than grainy.

You can mix the finer marble dust with the paint and apply it to the canvas with a painting knife. This provides greater volume but with a smoother finish.

You can also create a textured base with gesso or marble dust and, once it dries, you can paint over it with very diluted paint.

If you later paint over gesso with dry paint (undiluted), it deposits on the high areas and highlights the texture.

Oil with Volume:
Preparing a Relief

Fillers, which are made of different materials mixed with glue or latex, can be used to create relief effects. The paintings that incorporate charges are very expressive with a high level of texture and a low level of detail. Gesso is the most frequently used modeling paste; it is applied beforehand with a painting knife to define the volume of the clouds and some of the relief of the mountains, which will later be covered with oil paint.

DIFFICULTY	PREPARATION TIME
Medium	24 hours

INGREDIENTS

- Can of gesso
- Oil paints:
 yellow ocher
 cadmium orange
 cadmium yellow
 cinnabar green
 burnt umber
 cyan blue
 ultramarine blue
 cobalt violet
 burnt sienna
 white

UTENSILS

- Canvas board
- 2B graphite pencil
- Filbert brushes
 (fine and medium)
- Medium metal
 painting knife with
 a round tip

Preparation

1 We have chosen this subject on purpose because it is uncomplicated. No preliminary drawing is required; you only need to draw a few lines to define the outline of the mountains and a few others to lay out the clouds.

2 Apply impastos of gesso with the painting knife for the clouds and in the upper areas of the mountains. The goal is to form irregular reliefs with spontaneous applications.

3 The impastos represent the main features of the landscape in three dimensions, as if it were a bas-relief. Let the gesso base dry for about eight hours.

1

2

3
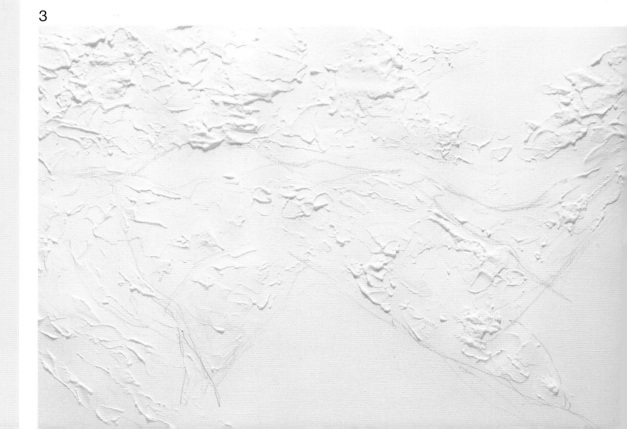

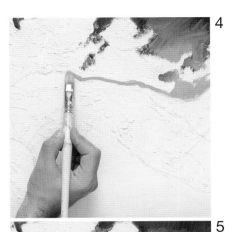

4

4 Paint the sky with ultramarine blue and cyan blue. Begin with the smooth areas, without relief, and define the silhouettes of the clouds.

5 The upper part of the sky is darker (ultramarine blue), whereas, the lower area, next to the mountains, can be painted with cyan blue lightened with white. The two blues form a perfect gradation.

6 Using gray mixed with white and small touches of violet, paint the shadows of the clouds leaving the illuminated areas unpainted, the color of the gesso. The rough texture of the impasto prevents the paint from spreading evenly.

5

7

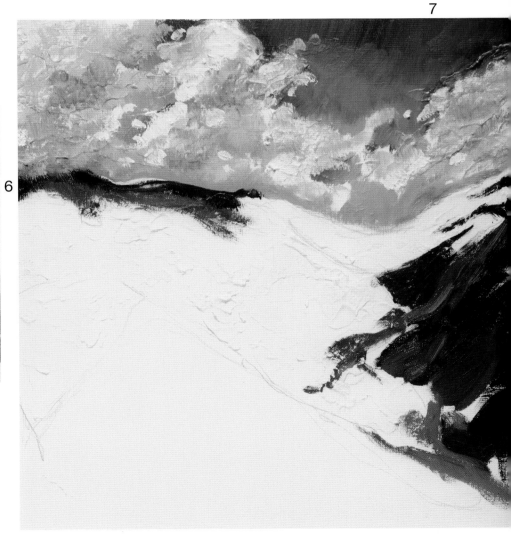

6

7 Finish painting the clouds using the same gray darkened with burnt umber and blue. Emphasize the dark area of the mountain's summit to show that a cloud is covering it partially.

8

9

10

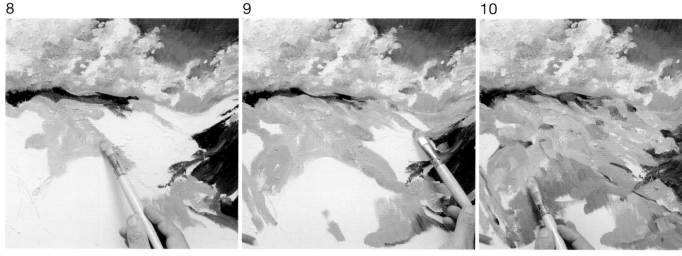

8 Paint the side of the mountain on the left with ocher mixed with white and a touch of gray and sienna. The texture of the gesso creates small voids or gaps that expose the white underneath.

9 With a greenish gray and a few very light touches of violet, build up the different intensities of light and color. For the time being, leave aside the vegetation and focus on the rocky areas.

10 Complete the gray areas with new orange ocher, green, and brown colors. The brushstrokes are not random; they should follow the descending direction of the sides of the mountains. Indicate the streams and crevices with lines.

11 Finally, the greens make their appearance, always mixed with ocher or white to downplay their contrast. At this point, the final touches are added with the thin brush to finish the painting.

11

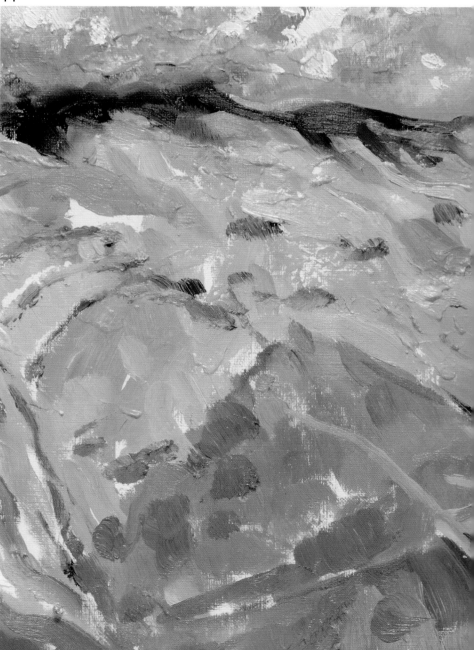

Advice

It is a good idea to work with creamy paint at all times. Use mineral spirits only to clean the brushes, not to dilute the paint.

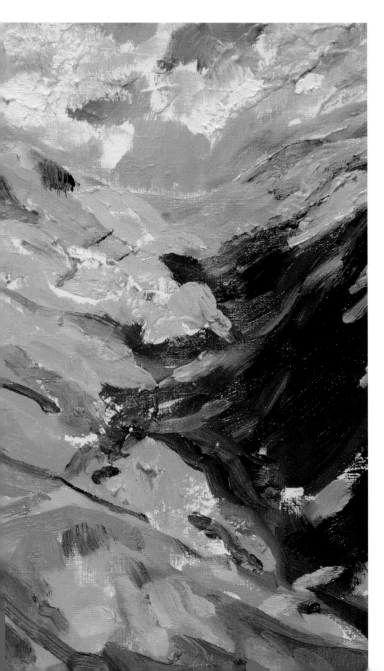

RECIPE CARD 1

PAINT ON THE HIGH AREAS

When the paint is undiluted, it can be applied to the areas of the texture that stand out to enhance the relief effect.

RECIPE CARD 2

STABILITY OF GESSO

Gesso is quite a stable material. Any mark that you make on the paste or any shape that you give to it does not change upon drying, although it does shrink by 25 percent.

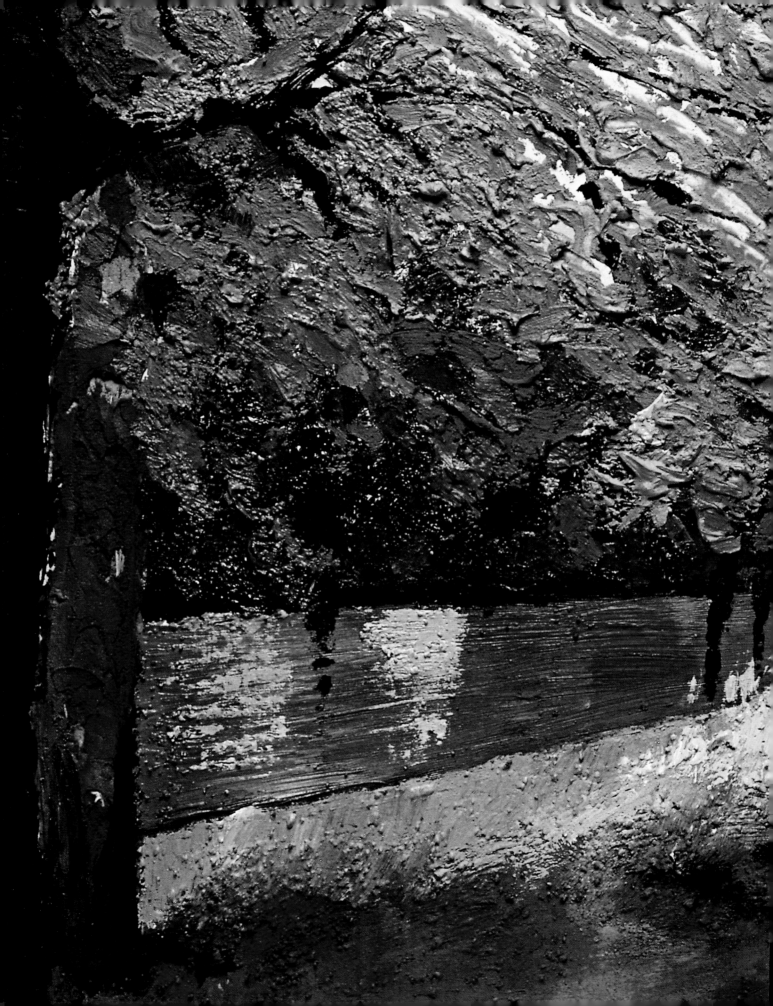

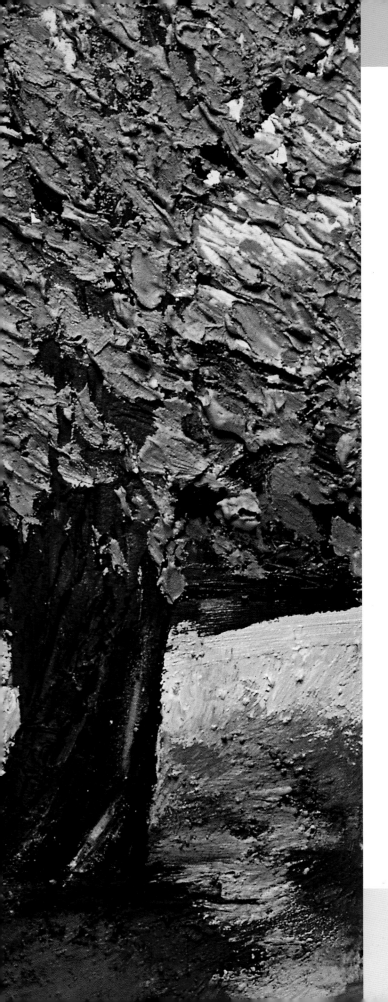

Acrylic

Forest
with Fillers and Acrylics

et us explore landscapes even further with more abrasive textures, mixing different modeling pastes and marble dust with acrylics, one of the media that best reacts to the addition of fillers. As you can see, mixing paint with different modeling pastes increases its thickness and its volume while barely altering the colors.

DIFFICULTY	PREPARATION TIME
High	5 hours

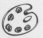

INGREDIENTS

- White gesso
- Fine-grain modeling paste
- Medium-grain modeling paste
- Acrylic paints: yellow ochrer, burnt sienna, emerald green, phthalo green burnt umber

UTENSILS

- Charcoal stick
- Metal painting knife
- Medium, round bristle brush
- Cardboard

Preparation

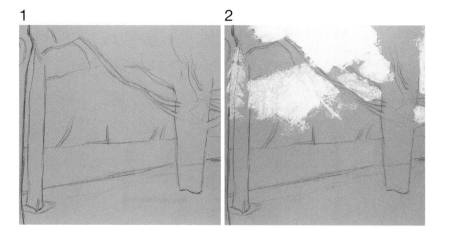

1 Outline the model on gray cardboard with a very simple drawing using a charcoal stick. It is not necessary to draw all the branches, only the main ones.

2 Apply a layer of white gesso over the sky with the metal painting knife. Work with the side of the blade, pressing hard to spread the paste thinly.

3 Cover the nearest tree trunks with fine-grain modeling paste mixed with yellow ocher and burnt umber. Make several passes with the round tip of the painting knife to form striations.

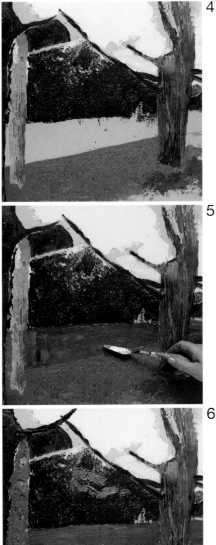

4

5

6

4 Cover the grass on the foreground with medium-grain modeling paste mixed with phthalo green and ocher. Use the same paste and emerald green to do the same with the dark vegetation over the other bank.

5 The function of the first layers of paint is to cover the support, to create a base with an overall color tone, so they should be applied relatively thinly and smoothly over the water and over the vegetation in the back.

6 Let the paint dry for half an hour before you touch up the color of the tree trunks on the left side with diluted acrylic paint. To do this, use a round bristle brush.

7 Prepare green paint mixed with a large amount of white. Combine it with a charge of fine-grain modeling paste and spread it with a brush over the grass. Paint the leaves with a new mixture of green and ocher, applying it with short and very heavy brushstrokes.

7

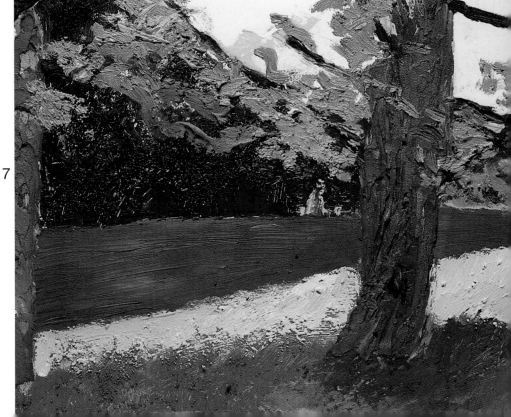

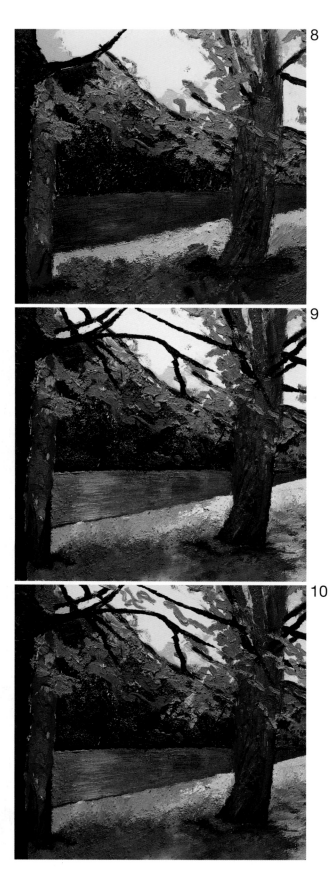

8

9

10

8 Using burnt sienna mixed with a small amount of white gesso (a very small amount), modify the color of the tree trunk on the right. Use that same color to paint the ground on the lower side of the painting.

9 Now mix the burnt sienna with a touch of ocher to create a more reddish and vibrant shade. With a few brushstrokes of that color complete the ground of the forest.

10 Go back to the leaves and paint them with green and fine-grain modeling paste. It is very important that the brush be a bristle brush because it is the most durable and the one that best withstands such an abrasive surface.

11

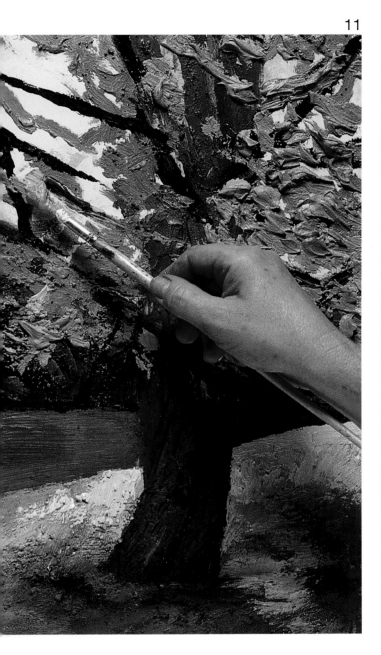

11 Charge the brush with a large amount of paint and spread it all onto the support while gently rotating movement of the handle.

RECIPE CARD 1

COLORS DARKEN

Paint mixed with the modeling paste tends to darken after it dries. Therefore, keep this in mind and try to apply the colors a little bit lighter than you expect them to look in reality

RECIPE CARD 2

ENHANCING THE TEXTURE

When the painting is finished, if you wish to further enhance the textured effect, simply apply diluted acrylic paint. It flows into the nooks and crannies creating contrast.

Striating Paint with a Painting Knife

When you use paint that is barely mixed and apply it to the support with a painting knife, the colors overlap and form bands or streaks that are very interesting visually. The painting looks like it is made of many different shades and minute colorful lines. This technique should only be used on very spontaneous and colorist paintings that do not require a delicate and detailed treatment. This work was done with acrylics.

A work created with the striated paint will never look boring because its entire surface looks like an explosion of colors.

One way to create unity to a painting full of colors is to drag the painting knife over the surface in a single direction, in this case, vertically.

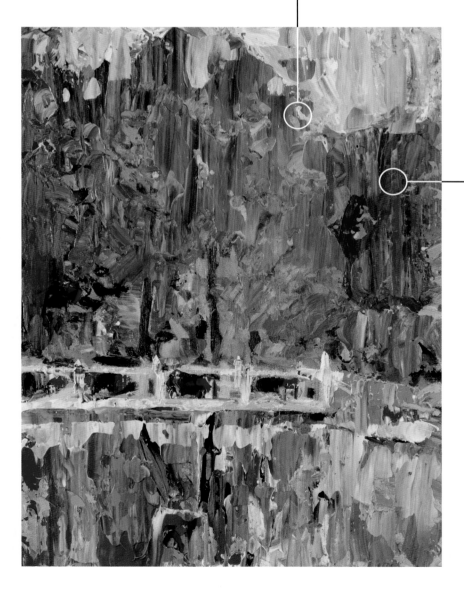

By pressing hard on the paint as it is dragged you can create a certain amount of transparency and the white of the support will begin to show through.

You can achieve this interesting effect if you shake your hand gently at the same time that you drag the paint.

You can line up different colors at one side of the paper. Then, use the edge of a metal painting knife to drag and spread them forming bands of well-defined colors.

Squirting the acrylic paint directly from the tube creates color bands that look organized and have some volume.

Dragging with a painting knife causes the colors to overlap and blend together, but the color in the centers of the strips remains unchanged.

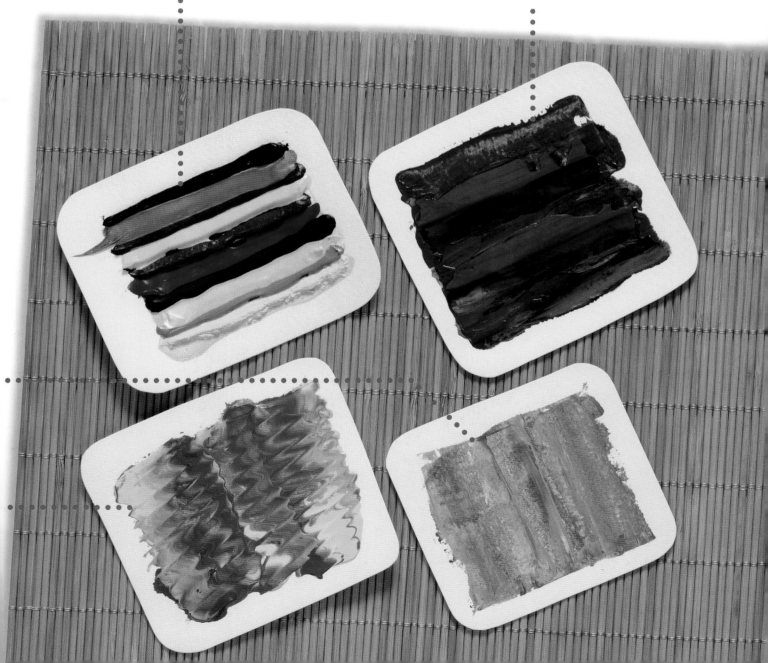

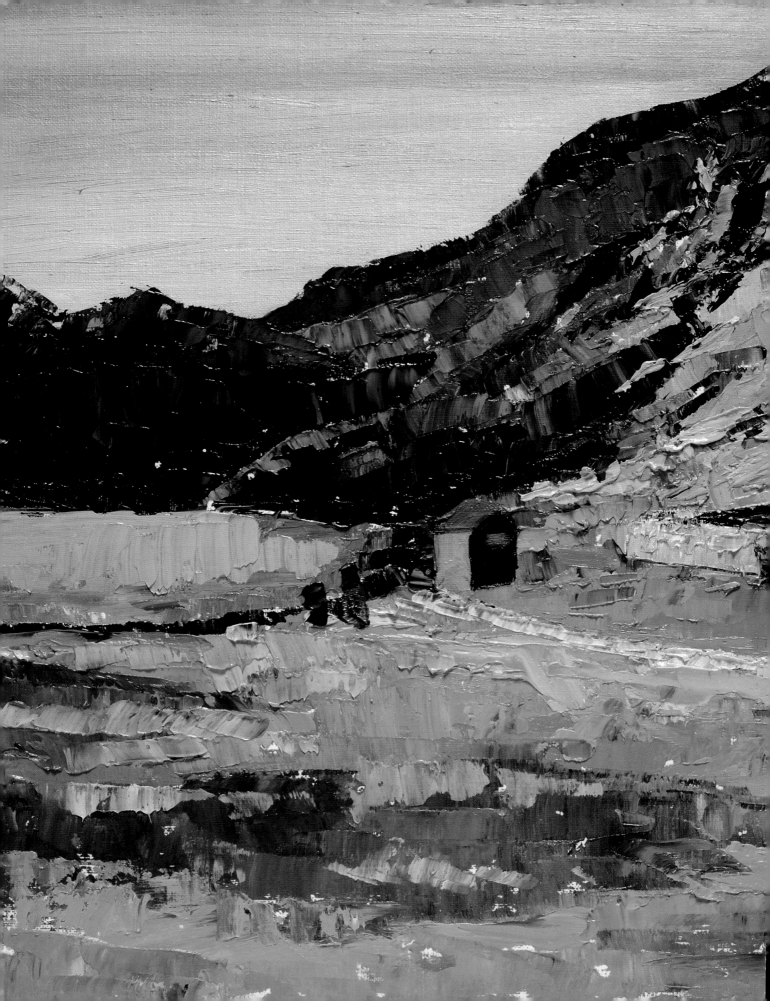

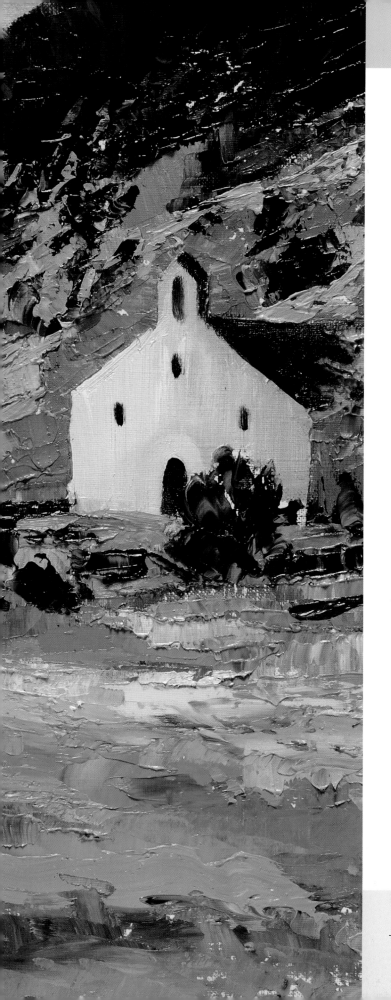

Oil Impasto with a Painting Knife

Oil impastos made with a painting knife are extremely attractive and give the painting a fragmented and textured appearance that people like very much. Any landscape done with this technique looks more vibrant and expressive and generates great expectation among artists. This type of painting should not take too long to complete: however, it is more difficult than others done only with brushes. Working with a painting knife requires great color sensibility and greater mastery of the hand movements that are used to deposit the paint on the canvas.

DIFFICULTY	PREPARATION TIME
High	3 hours

INGREDIENTS

- Oil paints:
 burnt umber
 mixed green
 cadmium orange
 cadmium red
 cadmium yellow
 cobalt blue
 cobalt violet
 sap green
 cyan blue
 burnt sienna
 magenta
 white

UTENSILS

- Canvas
- Stick of blue oil
 pastel
- Round-tip painting
 knife (small and
 medium)
- Medium flat brush
- Thin, round brush

Preparation

1 Make a preliminary drawing of the model with the oil pastel stick. A simple undulating line will define the mountains. The small church in the foreground requires greater attention.

2 Cover the sky with wide horizontal brushstrokes using a brush charged with a mixture of violet, a touch of carmine, and a large amount of white. The color should not be even and the different tones should be well blended.

3 With the small painting knife apply the different shades of green around the mountains. First, define the contours well to differentiate the mountains from the sky.

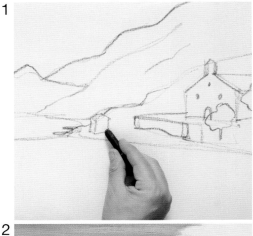

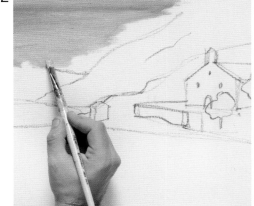

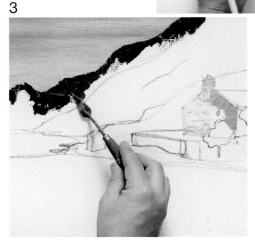

4

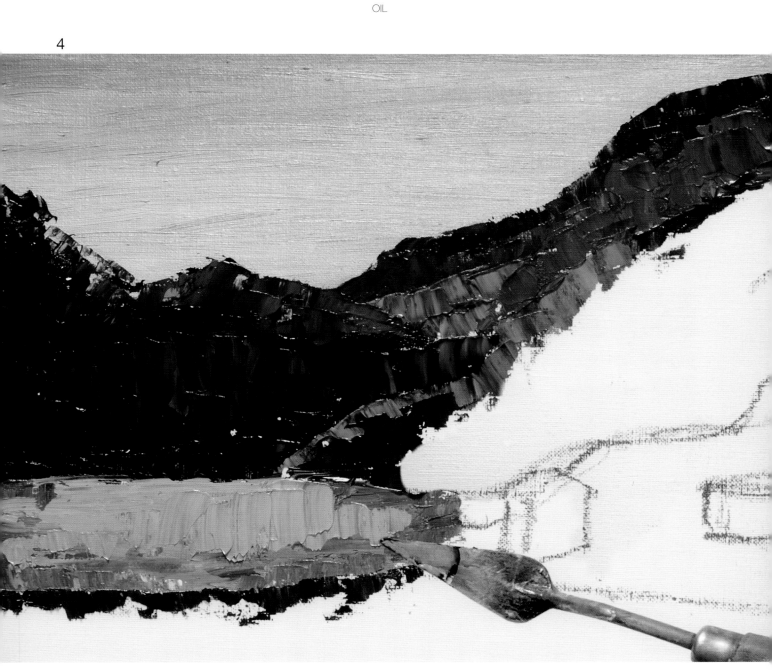

4 Apply the paint to the lake with the tip of the painting knife, dragging it flat and always from top to bottom.

Advice

Do not clean the painting knife with mineral spirits. To remove the remnants of paint wrap a rag around it and wipe it.

5 Add ocher and mixed green to lighten the various green tones. Now, the paint is applied with the edge of the painting knife, using short strokes with a lot of paint. Paint the walls of the small church with the brush.

6 Combine the mixed green, yellow, and ocher directly on the canvas. Pick up the paint with the medium painting knife and paint the nearest area of grass.

7 The darkest areas are created by adding a small amount of brown to the green. Work on the side of the mountain with the small painting knife, adding small touches of violet and orange tones.

8 Using the same painting knife, add new impasto layers of mixed green to the grass, and sketch in the stone wall around the church. Begin working on some of the trees with the tip of the painting knife charged with sap green.

5

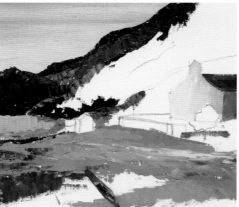

6

7

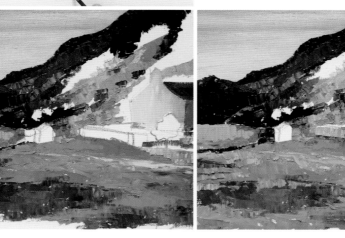

8

Advice

Painting the details and the very small areas requires a lot of practice, so we recommend using a brush to paint the walls of the church.

9 Slowly continue working on the hillside, adding more touches of sap green. Paint the autumn-colored tree on the right with orange and cadmium red.

9

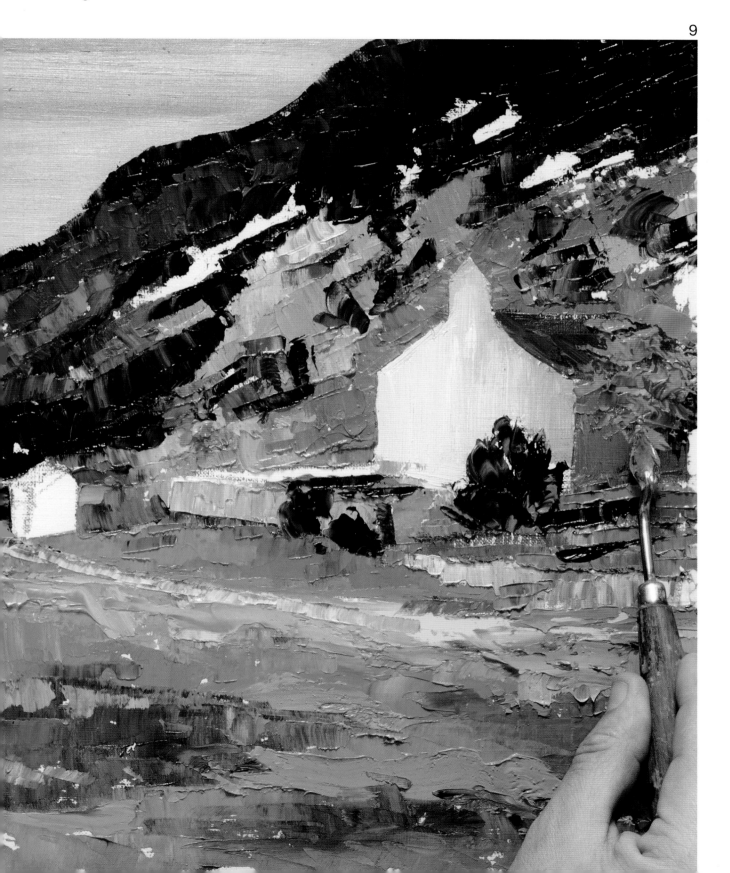

10

11

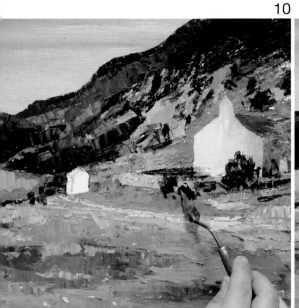

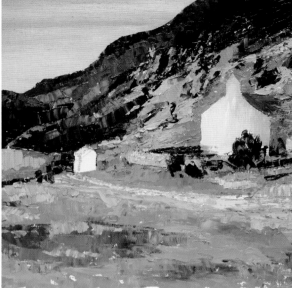

10 Paint the road with gray mixed with white and finish the stone wall that surrounds the small church. The painting knife's rounded tip allows you to add smaller dabs of color.

11 When the entire surface of the canvas is covered with paint, focus on the details, those that will help you highlight some of the texture or define contrasts, especially around the church.

12 Complete the small house by the lake and the doors and windows of the facade with a thin, round brush. The work done with a painting knife is not delicate enough to successfully resolve such small details.

12

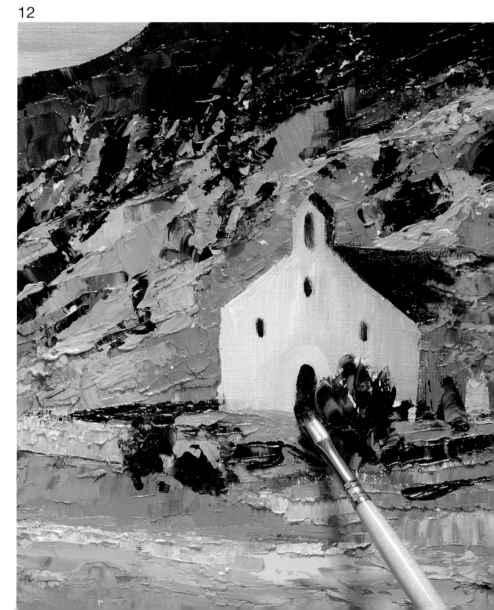

RECIPE CARD 1

ADDING FILLERS

Even though we have not used fillers in this exercise, it is important to remember that to make a medium coarser and more textured, you can simply add a small amount of marble dust to the paint.

RECIPE CARD 2

SEVERAL PAINTING KNIVES

When working with painting knives, it is a good idea to have several of different sizes and shapes for creating the best effects and details.

RECIPE CARD 3

CHANGES IN DIRECTION

To make very clear changes of planes, you should change the direction of the painting knife when you apply the paint.

RECIPE CARD 4

PAINTING WITH THE TIP

In the final painting stages you can use the rounded tip of the painting knife as if it were a brush to apply more accurate and precise details.

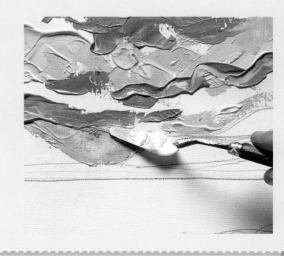

Suggestions

Acrylic

Dragging
Acrylic Paint

In this exercise with acrylics we combine the technique of dragging with a flat painting knife with the use of impastos in the foreground to enhance the texture and the effect of depth. The most important thing to remember about the dragging technique is that it will result in a general impression of the subject rather than a detailed version. The application of striated colors gives the composition a very vibrant feeling.

DIFFICULTY	PREPARATION TIME
High	3 hours

INGREDIENTS

- Acrylic paint:
 burnt umber
 phthalate red
 phthalate green
 ultramarine blue
 titanium white
 lemon yellow
 yellow ocher

UTENSILS

- Canvas
- 2B graphite pencil
- Medium metal
 painting knife

Preparation

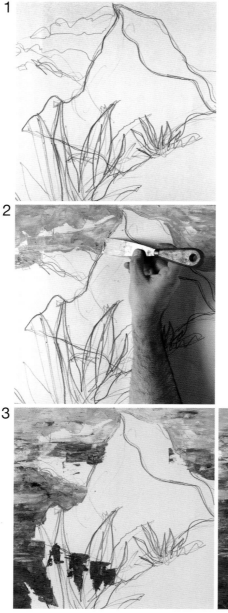

1 Draw the main forms of the landscape in heavy lines with the graphite pencil. The drawing should be seen as a guideline.

2 Begin painting the blue sea with an uneven mixture of ultramarine blue and white. Press hard on the painting knife, dragging the paint to create a very thin glaze.

3 Paint the water with gradations that should be lighter blue on the upper part. To darken it, apply a greater amount of ultramarine blue and a small amount of carmine so it turns more violet.

4 Put a small amount of green and ocher on the painting knife and drag it over the vegetation in the foreground. The goal is to create a base color over which the impastos and texture effects can be applied.

Advice

When dragging the paint with a flat painting knife it is important not to mix the colors too much to maintain the striated look.

5 Now you need dark violet to paint the shaded area of the rock. Paint all the shaded areas with a mixture of phthalate red, ultramarine blue, and, in lesser proportion, a touch of white.

5

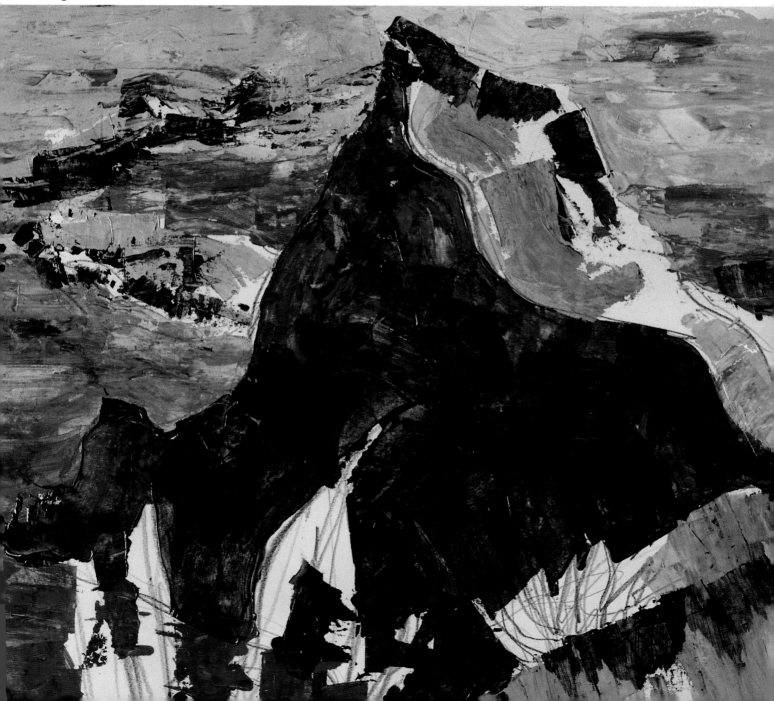

6

7

6 Complete the vegetation on the rock with a few dabs of alternating green and ocher. Highlight the areas of light on the rocks with orange ocher. The layer of dragged paint should be thin rather than an impasto.

7 Paint the vegetation nearby with thicker paint and more impasto. It is a good idea to charge the tip of the painting knife with a large amount of acrylic paint, hold it at an angle, and deposit the paint with a very short stroke, while barely applying any pressure.

8 Apply new impastos of yellow tones over the previous green. The vegetation should have rich and varied colors, and the outlines of the plants should stand out clearly against the blue background.

8

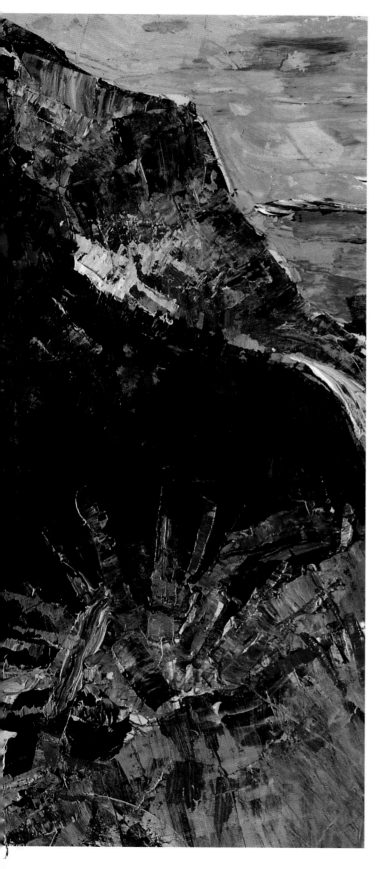

Suggestions

RECIPE CARD 1

STRAIGHT LINES

The leaves of the plants are painted by caressing the canvas with the tip of the painting knife charged with paint. The resulting lines will be more or less straight.

RECIPE CARD 2

MIXING WITH THE PAINTING KNIFE

You can create an interesting array of colors by firmly pressing on the painting knife while making a single pass. Do not make repeated passes to avoid ruining the effect.

First edition for the United States, Canada, and its territories and possessions published by Barron's Educational Series, Inc.

English language translation © Copyright 2011 by Barron's Educational Series, Inc.

Original title of the book in Spanish: *Recetas para pintar paisaje*
© Copyright 2010 ParramonPaidotribo—World Rights
Published by Parramon Paidotribo, S.L., Badalona, Spain

Design and Production: Parramón ediciones, S.A.
Editor In Chief: María Fernanda Canal
Editor: Mª Carmen Ramos
Texts: Gabriel Martín Roig
Exercises: Gabriel Martín and Almudena Carrion
Collection Design: Josep Guasch
Layout and Design: Estudi Guasch, S.L.
Photography: Nos & Soto
Production: Sagrafic, S.L.
Prepress: Pacmer, S.A.

English Translation: Michael Brunelle and Beatriz Cortabarria

All inquiries should be addressed to:
Barron's Educational Series, Inc.
250 Wireless Boulevard
Hauppauge, New York 11788
www.barronseduc.com

ISBN: 978-0-7641-6495-8

Library of Congress Catalog Card No. 2011936770

Printed in China
9 8 7 6 5 4 3 2 1

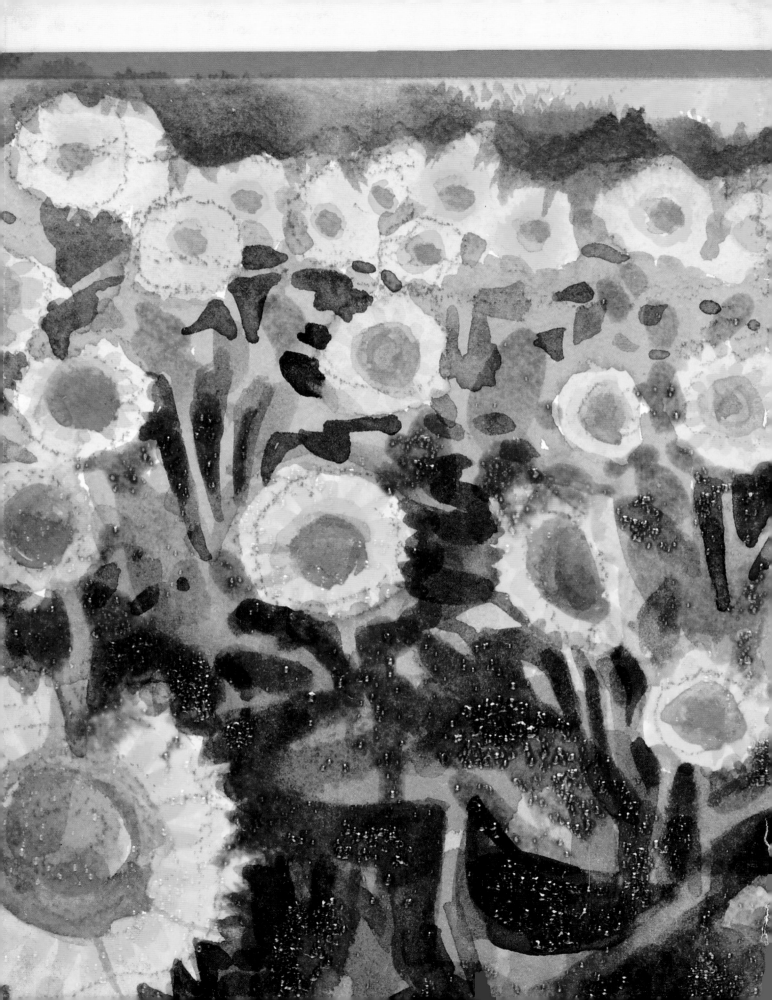